IMAGES
of America

BOULDER
1859–1919

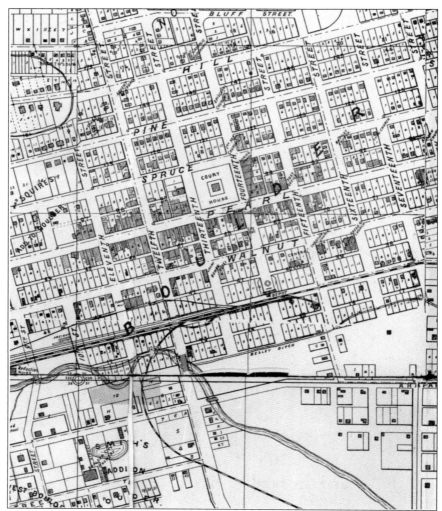

PLATTING A TOWN. Boulder's original 158.9-acre town site was a bounty land grant given to Revolutionary War veteran Joseph Weston. Since his widow, Sarah Weston, could not travel west, she assigned the certificate to Peter Housel before her death in 1862. Housel officially received the land patent in 1869, but he later exchanged it for land elsewhere in the Boulder Valley. Despite being squatters on this land, the first group of settlers formed the Boulder City Town Company on February 10, 1859. Shortly thereafter, the group platted out 1,280 acres of land along Boulder Creek, dividing it into 4,044 lots, with each lot measuring 50-by-140 feet. This 1898 map of Boulder shows the approximate boundaries of the town's original plat. The borders were roughly Hill (Mapleton) Street on the north, Valley Road (Arapahoe Avenue) on the south, Eleventh Street on the west, and Seventeenth Street on the east. (Courtesy Carnegie Branch Library for Local History.)

ON THE COVER: An unidentified group of women stop for a photograph below the Flatirons in Bluebell Canyon around 1915. Hiking near Chautauqua, these ladies were apparently on their "way for a beefsteak fry," which was a common ending to the more difficult hikes. Guided hikes and overnight mountain climbs were enjoyable activities for many Chautauqua visitors and local residents alike. (Courtesy Boulder Historical Society Collection.)

IMAGES
of America

BOULDER
1859–1919

Mona Lambrecht
and the Boulder History Museum

ARCADIA
PUBLISHING

Published by Arcadia Publishing
Charleston SC, Chicago IL, Portsmouth NH, San Francisco CA

Printed in the United States of America

Library of Congress Catalog Card Number: 2008928326

For all general information contact Arcadia Publishing at:
Telephone 843-853-2070
Fax 843-853-0044
E-mail sales@arcadiapublishing.com
For customer service and orders:
Toll-Free 1-888-313-2665

Visit us on the Internet at www.arcadiapublishing.com

For Rich

CONTENTS

ACKNOWLEDGMENTS

The book could not have come together without a partnership with the Boulder History Museum. Excited to take on this collaborative project, the museum's executive director, Nancy Geyer, allowed the photograph usage for this book, which will compliment the museum's goals of exploring and presenting Boulder's unique history. Thank you to Julie Schumaker for all the digitizing and to Peter Lundskow, who contacted Todd Stockwell at the Indiana State Museum about his farming expertise.

The Carnegie Branch Library for Local History in Boulder also played an important roll in this book. As the library's extensive collection grows through gracious donations of photographs and documents, it remains a constant source for fascinating research. Thanks to Wendy Hall, Marti Anderson, and Mary Jo Reitsema for all your guidance, suggestions, and knowledge. Thanks to the Boulder Genealogical Society, the Denver Public Library, and the Colorado Historical Society for the use of photographs and maps. Unless otherwise stated, all the photographs used in the book are credited to the Boulder Historical Society's collection.

A special thank-you goes to Silvia Pettem for sharing your vast knowledge of Boulder's history and keeping me on track. And a final thank-you to Rich von Sneidern, Horst and Gudrun Lambrecht, and Margie and Shannon Mayes for all your support in helping me bring this project together.

In addition to the bibliography at the back of the book, detailed citations of the primary source and unpublished collections I used are too numerous to include. Many of these sources include census records, city directories, maps, newspapers, yearbooks, deeds, advertisements, oral histories, and unpublished manuscripts.

INTRODUCTION

At the mouth of Boulder Canyon below the rock formation known as Red Rocks, a group of men organized the Boulder City Town Company on February 10, 1859. Discovering gold only one month earlier, these optimistic pioneers surveyed town lots, offering them at $1,000 each. Beginning humbly with a small collection of log cabins, the settlers that arrived the first year seemed undaunted by the scrappy appearance of the small frontier town.

Most of the earliest businesses resulted out of necessity. Merchants set up small general supply stores, and farmers dug ditches to irrigate their arid lands to grow grains and vegetables. Flour mills ground wheat for bread, and mail routes kept the mountain and valley communities connected. From the beginning, Boulder's existence relied on the success of the mountain gold mines and coal mines to the south. If the mining camps along Four Mile Canyon or near Marshall suffered then the residents could not pay for the goods and services Boulder offered. Growing pains lasted through most of the 1860s until a considerable silver strike in Caribou in 1869.

It took nearly a decade for both the mining communities and Boulder to become established. New mines were discovered, and more people migrated into Boulder, bringing in new businesses and new ideas. Town founders had high hopes for their little town. First, the arrival of the first train into Boulder in 1873 reignited Boulder's economy. Then after lobbying the Colorado Territorial Legislature and raising funds, Boulder finally became home to the University of Colorado, which opened its doors in 1877.

During the 1880s, Boulder continued to grow with the building of a narrow-gauge railroad to the mines in 1883. The town of more than 3,000 people was now connected to all the major cities and was eager to trade. Everything looked good for the community's farmers, ranchers, miners, and businesses until the spring of 1894. Heavy spring runoff combined with torrential rain to cause a massive flood that destroyed almost everything down Four Mile, Left Hand, and Boulder Canyons. The railroad up Four Mile Canyon was completely ripped out, towns were almost wiped off the map, and floodwaters submerged part of central Boulder and crushed all the bridges connecting the north and south parts of town. Devastated, it took communities months to rebuild, if they could rebuild at all. It took four years for another railroad to bring life to Four Mile Canyon again. Unfortunately, many mining towns suffered greatly, never again regaining their economic momentum.

Despite the hardships caused by the flood, Boulder teamed up with a group of Texans to open the Chautauqua in 1898. It rejuvenated Boulder, making it a different kind of tourist destination. Visitors traveled from around the country to spend the summer going to lectures, listening to concerts, watching dramatic performances, hiking in the foothills, and taking train excursions into the mountains.

As Boulder entered the modern era with telephones, electricity, and automobiles, it was becoming a sophisticated city. Expanding ideas in education, health, fitness, and transportation kept the town connected. However, by 1919, Boulder would witness some additional downturns even as the town thrived. In 1907, the Women's Christian Temperance Union won its battle against the

evils of alcohol, and Boulder became a "dry" city. Many Boulder men went to Europe to fight in World War I only to return to a devastating influenza epidemic when the war ended in November 1918. The toughest challenge came when the beloved Denver, Boulder, and Western "Switzerland Trail" Railroad ended its mountain operations in 1919.

Growing up in Boulder, I always had a fascination with the people who created the town. As an adult, my interest continues as I research to understand those individuals and families who endured harsh winters in the mining camps and those who faced the joys and hardships of building a town on the edge of a desolate prairie and a mountain wilderness.

Having access to more than 200,000 images in the Boulder History Museum's photography collection and narrowing it down to a 60-year time span became a challenge I did not expect. After looking at thousands of photographs, I condensed my topics, making every effort to provide an interesting cross-section of Boulder and its people. Unfortunately, my photographic limit was around 200 images, and there are hundreds of fascinating photographs that I wish I could have included. So I apologize to anyone who does not find a reference to a favorite person, place, building, topic, or church. I did my best.

Through photographs, this book provides a brief examination into what daily life was like for some of Boulder's citizens during the first 60 years of the town's development. Observing those first decades is crucial to understanding how Boulder was shaped by the decisions made by the men and women who lived there.

I hope this book inspires you to take a personal interest in the community around you and the importance of preserving Boulder's history for the future. Please consider contributing documents, photographs, or artifacts to the Boulder History Museum and the Carnegie Branch Library for Local History so that research for future publications can continue.

One

THE BIRTH OF
A SUPPLY TOWN

Rumors of gold in the western Kansas Territory (around Denver) enticed a group of men from Nebraska to venture west. The actual arrival date of the team, led by Capt. Thomas Aikens, is not clear, but by November 1858, a small camp had formed at the mouth of Boulder Canyon. Chief Niwot and the Southern Arapaho had seasonal campgrounds in the Boulder Valley, and none wanted the white men setting up camp nearby. Knowing the cycle of devastation these men and future settlers could bring, Niwot expected the men to leave the area the following spring, but the discovery of gold would change everything.

The Aikens party settled just north of the Kansas-Nebraska border on the 40th parallel (Baseline Road). Despite being squatters in Nebraska Territory, on February 10, 1859, sixty-one men, several from the original Aikens party, signed the Article of Organization, forming the Boulder City Town Company.

Within Boulder's first years, most men attempted mining, while others knew that profits would come from supplying the miners. Despite being called a "hideous collection of frame houses on a burning plain" by English traveler Isabella Bird in 1873, Boulder's businesses grew, the town became the proud location for the state's first university, and the population soared to more than 3,000 people by the end of the decade.

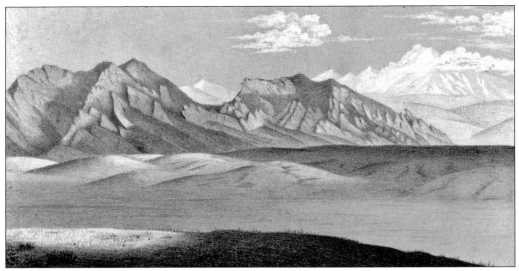

BOULDER VALLEY AND THE FIRST SETTLERS. Before the first permanent white settlers arrived, the Front Range and Boulder Valley (above) were the winter campgrounds to bands of the Southern Arapaho and were likely explored by trappers, traders, and soldiers from the military forts along the South Platte River. During the early winter of 1858, Alfred A. Brookfield (below, left) and Capt. Thomas Aikens (below, right), were among the first white men to set up a permanent camp at the mouth of Boulder Creek. Aikens, a farmer from Maryland, led the exploration team to the Boulder Valley and later settled in Valmont. Brookfield, a grocer and Nebraska City mayor, became the first elected president of the newly formed Boulder City Town Company. (Illustration above courtesy Denver Public Library, Western History Collection, Alfred Edward Mathews, Z-8824.)

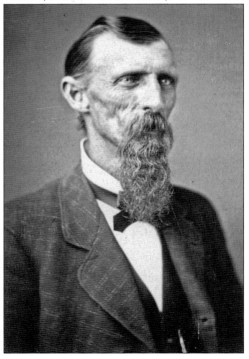 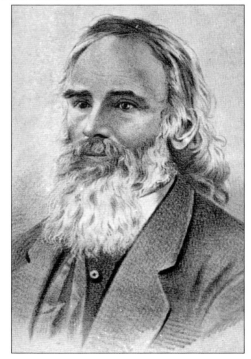

FIRST CAMP NEAR RED ROCKS. Historians believe Capt. Thomas Aikens and his men set up their tents near the confluence of Sunshine and Boulder Creeks. This area is near the mouth of Boulder Canyon and below the rock outcropping known as Red Rocks. The general location has historically been associated with the Aikens's camp, but the exact location of the camp site is unknown.

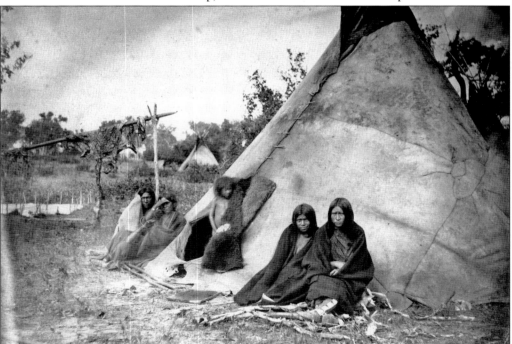

SOUTHERN ARAPAHO LANDS. Thomas Aikens's group arrived in the Boulder Valley as the winter of 1858 approached, just as Chief Niwot (also known as Chief Left Hand) and his people were settling into their winter campgrounds. Wary of the white men's intentions, Niwot received assurance from Aikens that they would only stay the winter then prospect in the mountains the following spring. (Courtesy Denver Public Library, Western History Collection, X-32133.)

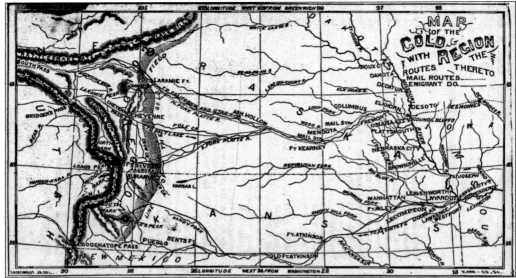

PIKES PEAK OR BUST. As news spread of the January 1859 gold strikes in the Kansas and Nebraska Territories, businessmen such as William Byers compiled handbooks informing gold seekers about routes and supplies. The trail along the South Platte River became the most popular and reliable. Arriving at Fort St. Vrain, travelers either continued to Boulder or went south to Denver and Auraria. (Courtesy Colorado Historical Society, RB 978.8022 B991h 1859, 3000668.)

GOLD SEEKERS ARRIVE. By July 1860, more than 850 men, women, and children lived in the greater Boulder area. Most men mined in the foothills, while the handful of merchants, blacksmiths, and butchers opened stores along Pearl Street and farmers plowed their fields near Valmont. The 1860 census shows that Boulder's residents mostly came from the Midwest, East Coast, and many western European countries. (Courtesy Denver Public Library, Western History Collection, X-21803.)

NATIVE AMERICAN TENSIONS, 1864. In September 1864, the seven leaders pictured here are of the Southern Arapaho and Cheyenne, who met with Gov. John Evans to discuss a peace agreement. Little negotiation took place, and on the morning of November 29, the Third Colorado Cavalry killed 148 Arapaho and Cheyenne, mostly women and children, at Sand Creek. There were 46 men from Boulder. Two died along with Chief Niwot. (Courtesy Denver Public Library, Western History Collection, X-32364.)

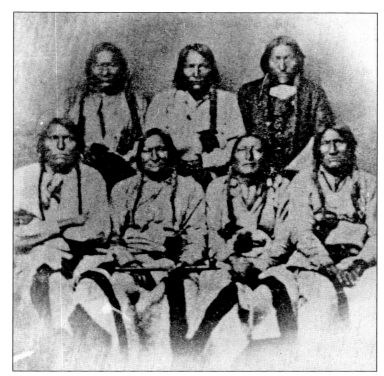

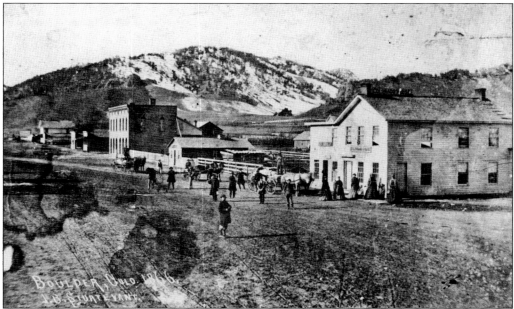

BOULDER, EARLIEST KNOWN PHOTOGRAPH. This sparse 1866 view looking northwest from Thirteenth and Pearl Streets shows a crowd gathered at the Colorado House hotel. Daniel Pound built the hotel around 1863. His sons William and Ephraim operated the hotel until 1871, when they sold it to Alfred A. Brookfield for $4,000. In 1881, Brookfield dismantled the Colorado House and replaced it with a two-story brick structure.

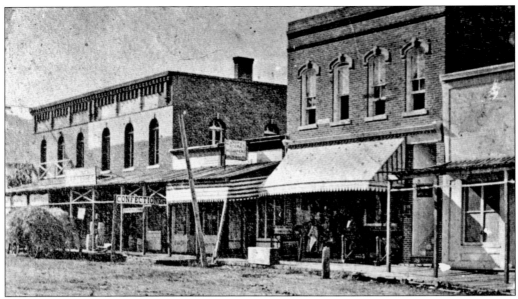

PEARL STREET, 1870. The north side of the 1200 block of Pearl Street (above) shows Boulder's first brick structure, built in 1866, the Dabney-Macky building at the far left. It was on the corner of Twelfth (Broadway) and Pearl Streets and was named for builders Charles Dabney (below, left) and Andrew J. Macky (below, right), two of Boulder's prominent pioneers and businessmen. First arriving in Gold Hill in 1860 and then Boulder in 1864, Dabney worked as a miner, blacksmith, postmaster, and county commissioner, finally making his money in real estate. Macky built many of Boulder's early important structures, but ultimately, he made his mark as the president of the First National Bank, a public official, and a promoter of the University of Colorado. (Below, right courtesy Boulder Genealogical Society.)

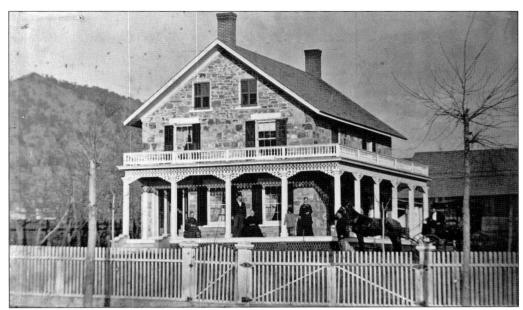

SQUIRES-TOURTELLOT HOUSE.
Constructed of local river rock in 1865 and built at 1019 Spruce Street, this is Boulder's oldest surviving stone house (above). Frederick A. Squires (right) and Jonathan A. Tourtellot married twin sisters Miranda and Maria Wade. Originally from New England, the families arrived in the spring of 1860 and opened a general store in a log building at the corner of Eleventh and Pearl Streets. The wives managed a small hotel behind the store and provided hot meals and a touch of home for grateful miners. In 1866, the men engaged in successful lumber, mining, and mercantile businesses until 1870, when Tourtellot died and Squires sold the sawmill. Squires became a prominent merchant, and when the town incorporated in 1871, he became the first Town Board of Trustees president.

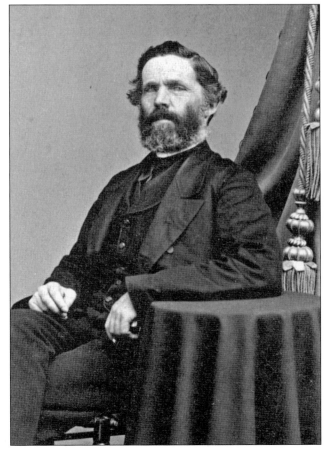

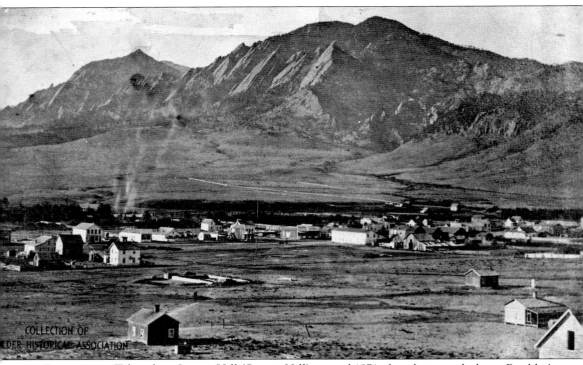

PANORAMA. Taken from Lovers Hill (Sunset Hill) around 1871, this photograph shows Boulder's sparse landscape, with the only trees indicating the location of Boulder Creek far in the background. The long rectangular building seen in the above center is the Colorado House hotel at the corner of Thirteenth and Pearl Streets. Closer to the left foreground is the foundation work for

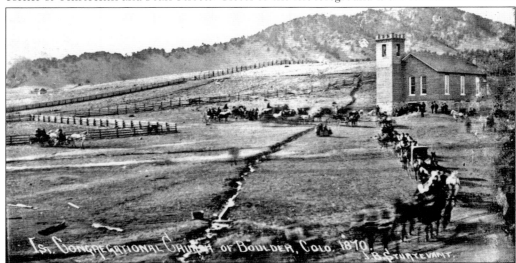

FIRST CHURCH BUILT IN BOULDER. Early religious gatherings were rather informal, with local congregations meeting in homes or schools. In 1868, the First Congregational Church held its first service in the new church, despite it being unfinished. It remained at 1125 Pine Street, where the Carnegie Library stands today, until 1908 when a new church was constructed across the street on the southwest corner of Twelfth (Broadway) and Pine Streets.

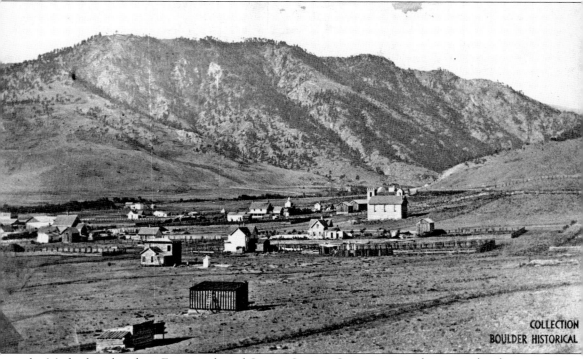

the Methodist church at Fourteenth and Spruce Streets. Continuing to the west side of town, the most prominent structure in view is the First Congregational Church with its bell tower just right of center along Pine Street. Continuing diagonally to the foreground, on Pine Street are the houses of Andrew J. Macky and James P. Maxwell at 1201 and 1235 Pine Street, respectively.

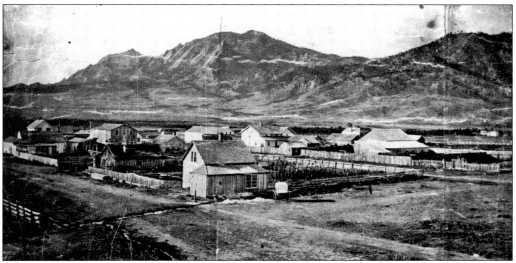

DOWNTOWN BOULDER, C. 1870. Some of Boulder's earliest wooden buildings are in this southwest view from the corner of Twelfth (Broadway) and Spruce Streets. Note the family gardens and fences keeping out free-roaming livestock. Ben Williams's blacksmith shop is the dark-roofed building to the left of the corner house, and the Boulder House at Eleventh and Pearl Streets is at mid range in the center of the photograph.

17

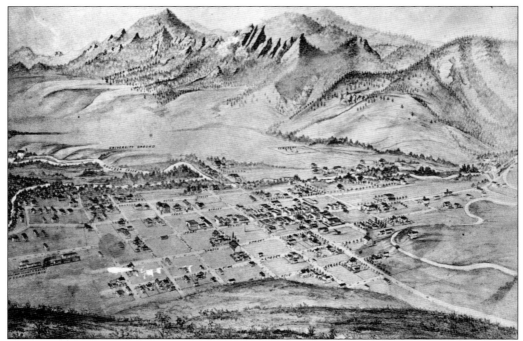

BIRD'S-EYE VIEW, 1876. This E. S. Glover illustration shows the concentration of Boulder's central business district and how the town was expanding. The early train depot is at the lower left, the university grounds and cemetery are in the background, and the Farmer's Ditch curves along the lower right. The lack of a university building on this map indicates that Old Main was still under construction.

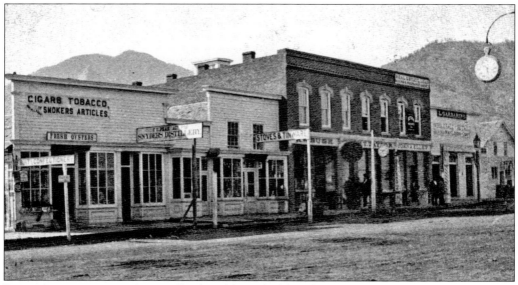

PEARL STREET, C. 1876. A mix of brick and frame buildings house some of Boulder's early businesses on the south side of the 1100 block of Pearl Street. Businesses include Snyder's Distillery, A. W. Bush and Company jewelers, the real estate office of John A. Ellet, and the rambunctious, yet popular Louis Garbarino saloon at the far right of the block.

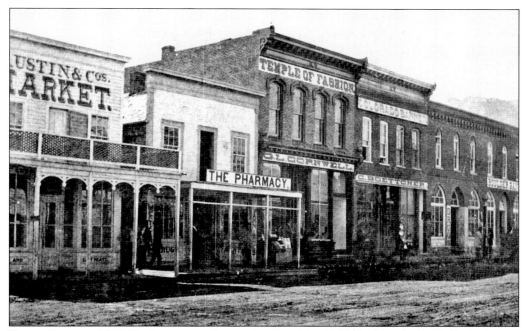

PEARL STREET, 1877. Businesses on the south side of the 1200 block include the E. A. Austin Market, the Temple of Fashion, Charles Boettcher's Crockery Store, and the offices of the *Colorado Banner* newspaper above Boettcher's shop. Each store owner was responsible for the wooden sidewalk in front of his own store, which accounts for the problematic variations in walkway height.

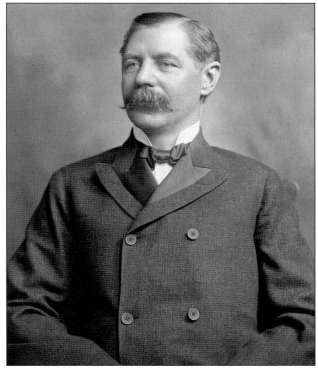

CHARLES BOETTCHER, C. 1890. In 1869, at the age of 17, German-born Charles followed his older brother Herman to America, and by 1873, they arrived in Boulder, opening a hardware store. Customers enjoyed an extensive stock of items displayed in beautiful showrooms. Charles left for Leadville in 1879 and later became one of Colorado's most successful businessmen. (Courtesy Denver Public Library, Western History Collection, Rose and Hopkins, H-13.)

MAPLETON HILL, C. 1877. This view to the west shows a treeless Hill (Mapleton) Street before the planting of 1,500 maple trees in the spring of 1889. Located in the left background is the First Congregational Church at Pine and Twelfth (Broadway) Streets. The home of Judge James A. Decker in the left foreground shows early construction techniques.

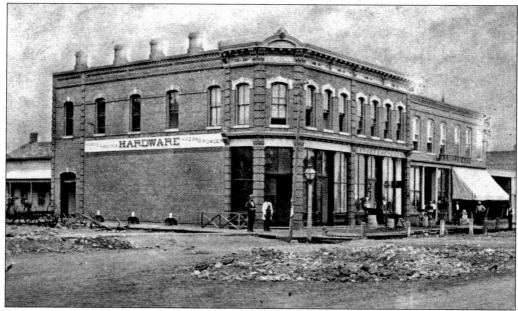

WELCH BUILDING, C. 1877. On this site in 1860 Andrew Macky built Boulder's first frame house, which also served part-time as Boulder's first courthouse. In 1875, A. L. Welch razed the house at Fourteenth and Pearl Streets to erect this building, where he operated Welch and Company, a hardware and dry-goods store.

Two

GOLD, SILVER, AND COAL

During the fall of 1858, news of gold discoveries by the William Green Russell party along the South Platte River and Cherry Creek (Denver) sparked the Pikes Peak gold rush. Eager argonauts arrived but were disappointed when they learned of Russell's meager findings. Thousands returned to the east, but many persisted and followed the rivers west into the mountains. In January 1859, there were three significant and independent gold finds: one along the south branch of Clear Creek (near Idaho Springs), another on the north fork of Clear Creek (near Central City), and a third along the tributaries of Boulder Creek (near Boulder). By the summer of 1859, thousands arrived, reigniting the rush for gold.

Gold mining camps dotted the landscape as more fortune seekers arrived in the Boulder region. A large silver strike in Caribou began another mining boom in 1869. Three years later, tellurium was found alongside the gold and silver ores. Originally perceived as worthless quartz, new assaying methods uncovered the presence of a valuable alloy ore used for improving the performance of other metals.

Coal proved to be another valuable resource for the Boulder region. Discovered in 1859 south of Boulder at Marshall, this area of coal was part of a huge coal field extending south to Colorado Springs. Most of the area's operating coal mines were around Marshall, Louisville, Lafayette, and Erie, and supplied Boulder and Denver's heating needs.

Fluctuating prices of precious metals and minerals, panics in the market, and natural disasters took a toll on Boulder and the surrounding communities. When the government repealed the Sherman Silver Purchase Act in 1893, silver prices plummeted as the country resumed the gold standard. There was no longer a guaranteed price for silver. The flood of 1894 destroyed many mining camps and washed out the railroads supplying the canyon towns. Many camps did not recover from the flood, and those that did struggled to remain profitable.

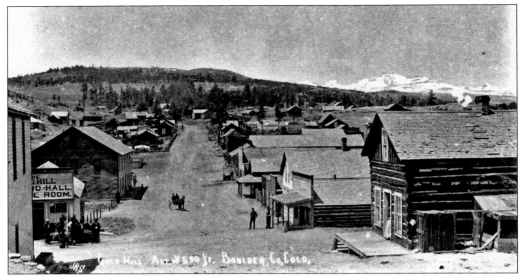

GOLD HILL, 1880s. In January 1859, members of the Aikens party found gold at Gold Run, a small creek bed between Sunshine and Four Mile Canyons. It became one of several regional strikes that occurred during the month, sparking the rush for gold. Miners quickly formed a government similar to the mining districts in California, and on March 7, 1859, they established Mountain District No. 1, Nebraska Territory.

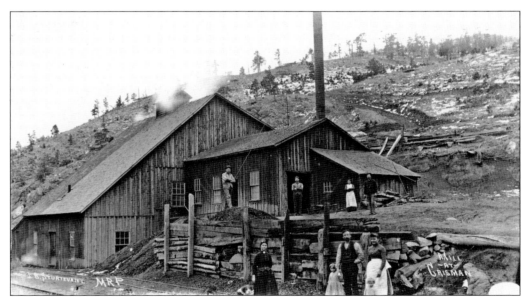

NEIKIRK MILL, C. 1880s. Prior to the formation of the town of Crisman (originally Camp Tellurium), the Yellow Pine and Logan Mines began producing gold and tellurium ores in 1874. Located up Four Mile Canyon, Obediah Crisman built the first ore processing mill in the late 1870s, giving the town its name. The Neikirk Mill, owned by Henry Neikirk in the 1880s, also went by the name of the Crisman Concentration Works.

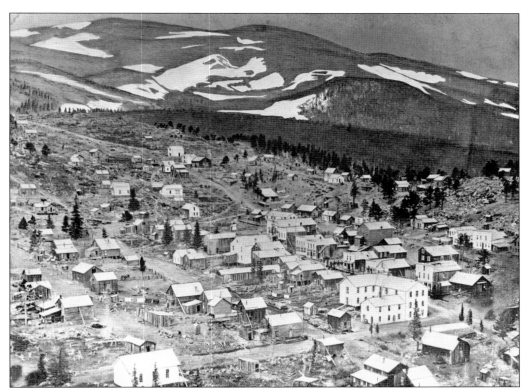

CARIBOU, 1878. At 10,500 feet above sea level and four miles north of Nederland, a silver strike in the fall of 1869 put the windswept town of Caribou on the map. The hearty residents of this boomtown enjoyed early wealth; however, they also endured harsh winters, epidemics, declining silver prices, and devastating fires. The town deteriorated but survived another 35 years, when a fire finally destroyed it in 1905.

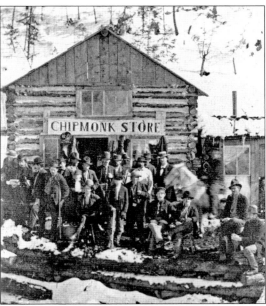

BALARAT, C. 1880. Located along a narrow road north of Jamestown, the Smuggler Mine (discovered in 1875) was one of several mines around the isolated town of Balarat. Aside from family homes and boardinghouses, the only other businesses were a meat market, a saloon, and the small general store shown here. The spring flood of 1894 destroyed the town, but a few of the mines and people remained for several more decades.

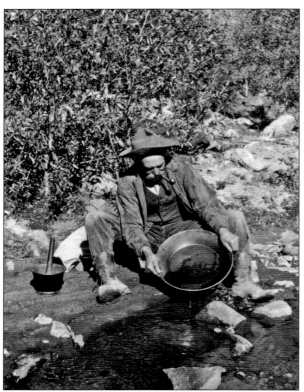

PANNING FOR GOLD, 1908. This typical prospecting technique focused on uncovering gold dust or nuggets that washed down from the source. Miners often followed the loose gold deposits upstream to locate an original gold vein. Panning involved swirling dirt and gravel with water in a large pan, which gradually washed the dirt away, leaving the heavy gold in the bottom of the pan.

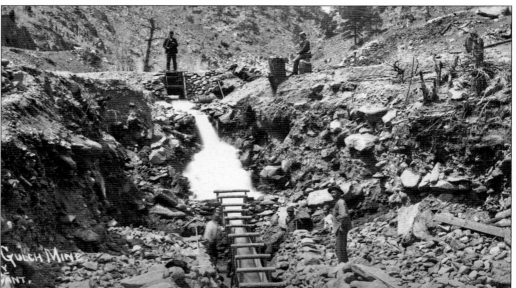

SLUICE BOX, C. 1885. Based on the same principle as panning, a sluice was a more efficient method of separating gold from rocks and dirt. One of the few photographs of Chinese miners shows how diverted river water flushed through the wooden troughs. Miners would shovel dirt into the sluice, and ridges on the bottom of the trough caught the heavier gold as the water rinsed away the dirt.

WIDOW MAKER, C. 1890. While miners confronted death in the mines daily, another threat was slowly killing them from the inside. A typical turn-of-the-19th-century compressed air drill, known as the "widow maker," would expel so much rock dust when used that over time men's lungs became clogged. Known as miner's consumption, many miners died slowly from this respiratory disease, now known as silicosis.

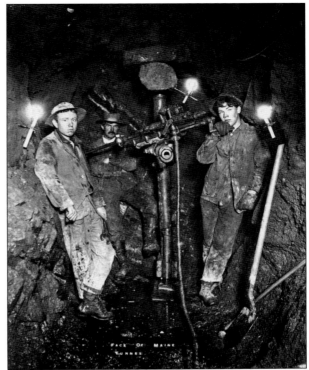

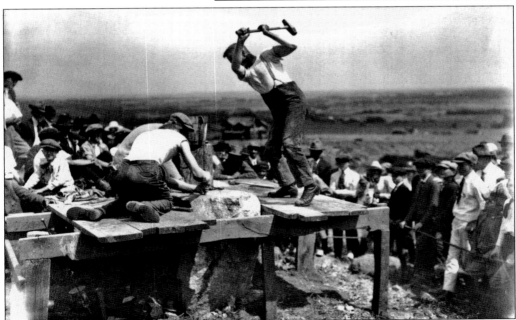

DOUBLE-JACK DRILLING, 1919. This type of drilling was an early two-man method of boring blast holes in mine tunnels. One man held a sharpened steel bit for the striker, and with each hammer blow and a turn of the bit, the steel would go a little deeper. This rock-drilling competition demonstrated the strength, precision, and skill needed to work the hard-rock mines.

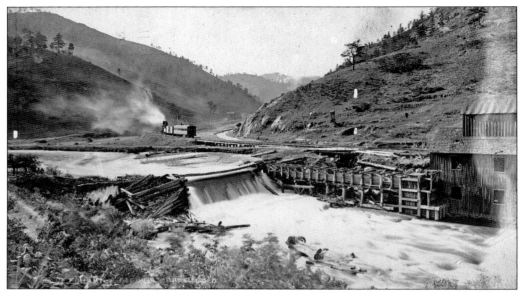

ORODELFAN MILL, BEFORE 1894. Standing where Four Mile Creek enters Boulder Creek, the building at the right began as a sawmill during the 1860s. In 1870, the Hunt, Barber, and Company purchased the mill and developed a smelting operation. Complete destruction of the smelter occurred during the spring flood of 1894. A wall of water rushed down Four Mile Canyon taking out everything in its path, including the dam and the canyon railroad tracks.

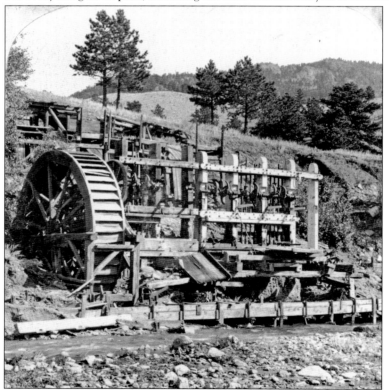

GOLDEN AGE MILL, BEFORE 1894. Most of Colorado's gold was a combination of quartz rock and gold, making it difficult to extract the valuable metal. Located near Jamestown, this stamp mill crushed the stone, separating the ores for easier processing at the smelters. (Courtesy Denver Public Library, Western History Collection, A. E. Dickerson, X-60740.)

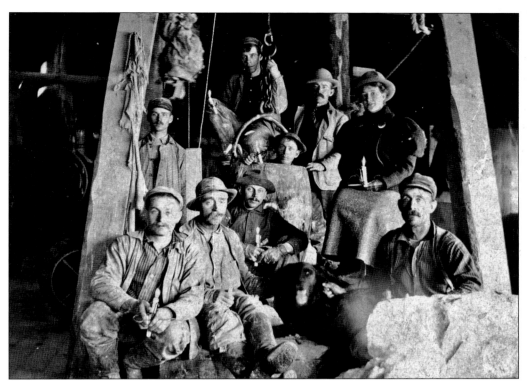

DESCENDING INTO THE MINES, C. 1890.
As mines expanded in size, miners drilled vertical shafts for machinery, ventilation, and to transport workers. Inside the shaft house, miners rode ore buckets (or skips) down into the multiple tunnels below. Identified men at the Tillie Butzel Mine at Sunshine (above) are Frank Shea, sitting on top of the bucket; Frank Marshall, in the bucket; Ed Jones, at the front far left; Edward T. Jones, in front of the bucket; and Johnnie Jones, at front far right. A smaller ore bucket required more balance to ride, as shown by men at Sunshine's Monongahela Mine (right).

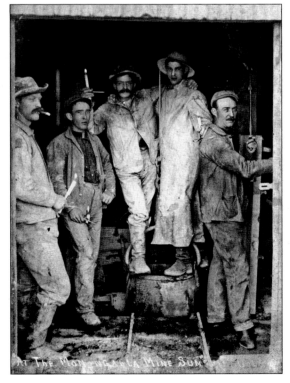

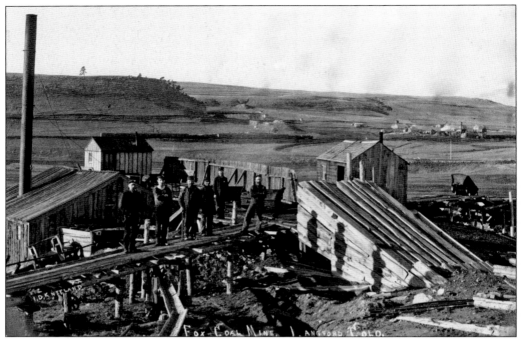

FOX COAL MINE, C. 1890. Located approximately five miles south of Boulder, the mines in Marshall produced much of the first coal in Colorado. The town of Marshall went by a variety of names over the years, including Langford, Gorham, and Foxtown because of the large Fox Mine. (Courtesy Carnegie Branch Library for Local History.)

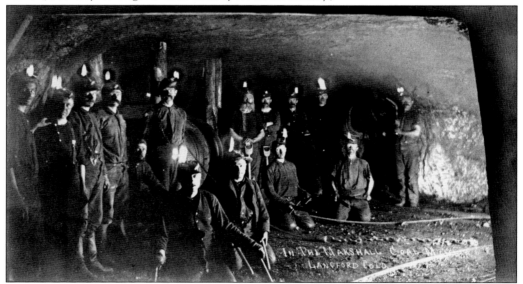

INSIDE THE MARSHALL MINE, 1880s. The mine was named after Joseph Marshall, who owned the Consolidated Coal Company. Marshall made millions from his coal and iron ore mines, while his miners often lived in near poverty. Earning little, miners typically found themselves forced to live in company camps where food and goods were expensive. It was not uncommon for a man to owe the company money at the end of the month.

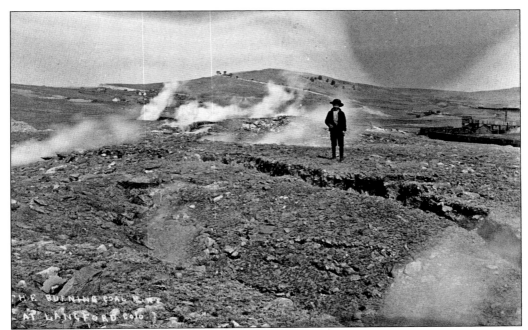

BURNING COAL MINE, 1880s. Coal mining has always been a dangerous occupation, with threats of explosions, cave-ins, falling rocks, or men getting crushed by ore carts. In the Marshall-area mines, fire was a constant problem. A fire originated in some of the mine tunnels in 1869, and because of the continual supply of fuel, it is still burning. (Courtesy Carnegie Branch Library for Local History.)

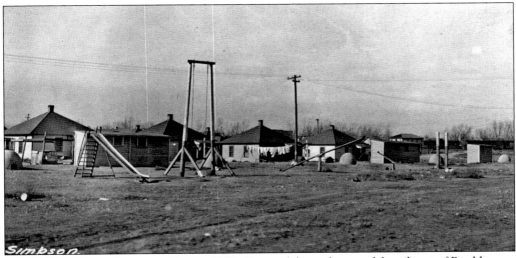

PLAYGROUND IN A COMPANY TOWN, 1913. Some of the earliest coal found east of Boulder was on the Miller farm in 1884. By 1887, John Simpson dug the first shaft, discovering the Simpson Mine, at what is today the center of Old Town Lafayette. The Rocky Mountain Fuel Company operated most of the coal mines in Lafayette. Miners and their families typically lived in company housing and shopped at authorized stores.

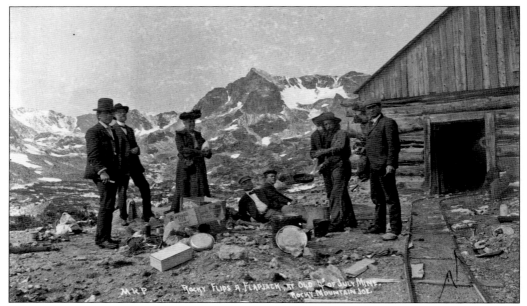

FOURTH OF JULY MINE, C. 1890. With Arapaho Glacier and the Continental Divide as a backdrop, this mine, located above the timberline, earned the distinction of being at the highest altitude in Boulder County. Discovered in either 1872 or 1875, the silver mine closed when it became unprofitable but reopened in 1900 when the Consolidated Copper Mining Company found copper. The only identifiable person is the photographer, Joseph Sturtevant, seen second from the right.

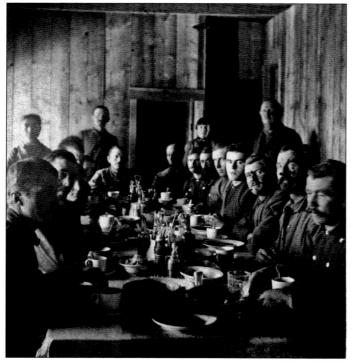

BOARDINGHOUSE, C. 1881. Typically operated by women, camp boardinghouses provided room and board to miners who were unmarried or were working away from their families. While these rooming houses provided men with hot meals and a much-needed touch of home, they also provided a suddenly widowed woman an easy method of supporting her family by renting out rooms in her house.

MINING TOWN SALOONS, C. 1893. In small and remote camps, saloons provided places for rest, relaxation, and socialization. Occasionally, they served as banks and even churches. Alcohol consumption allowed miners to socialize, and while these men enjoying beer in Salina (above) and Jamestown (below) appear jovial, rowdiness and violence remained constant problems. As more families resided in the mining camps, women's temperance groups fought vigilantly for Prohibition. What began as limiting a saloon's hours of operation ended in victory for temperance organizations when they succeeded in a statewide ban of alcohol in 1916, four years before nationwide Prohibition.

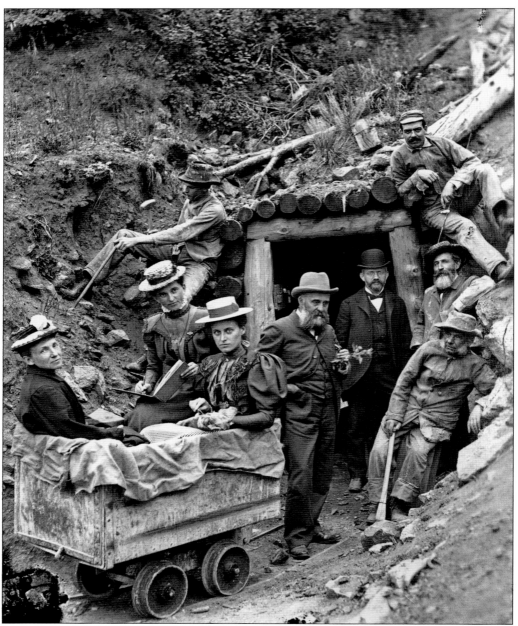

LOGAN MINE, c. 1897. Discovered in 1874 above Four Mile Canyon, the Logan Mine produced some of Colorado's highest grade gold ore. In 1897, new owners Charles Culbertson, Samuel Dick, William Hayes, and Thomas Mann purchased the Logan and revived the mine. After the 1894 flood destroyed the Greeley, Salt Lake, and Pacific Railroad line up Four Mile Canyon, these men were influential in developing the new Colorado and Northwestern Railroad and in creating the Culberston ore processing mill south of Valmont. By 1900, the mine was producing so much quality gold ore that secured train cars made weekly trips to Denver, with many shipments going directly to the mint. Some of these unidentified men and women posing at one of the Logan tunnel entrances might be the new owners and their wives.

Three

BALANCING WATER AND AGRICULTURE

During Maj. Stephen Long's westward exploration in 1820, he called the eastern plains, of what would become Colorado, part of the "Great American Desert." He saw little value in the arid climate, finding the landscape "totally unfit for cultivation" and "uninhabitable by a people depending on agriculture." This label would delay settlement in the region for decades.

Boulder's first farmers settled near creeks where they hoped to retain a reliable source of water. Because of the inconsistent rains, farmers captured water from the spring runoff in a system of irrigation ditches. By the end of 1859, three ditches extended the water supply to farmers. As ditch digging increased, farmers began broadening their selection of crops to include varieties of fruits and vegetables not thought to thrive in the dry climate.

Ditches and smaller canals also extended into many town neighborhoods, providing residents easier access to water. The growing need for water and the desire for better water pressure prompted the building of a reservoir near the mouth of Boulder Canyon.

Boulder's economy gradually became closely linked to agriculture. Farms not only supplied food for the town and mining communities, but they also supplied grains for animal feed, flour mills, and breweries. Having ranches nearby allowed town butchers access to fresh meat, and by the 1870s, dairy farms surfaced, supplying Boulder with fresh milk, butter, and cheese. By the turn of the 20th century, flower farms and greenhouses had gained in popularity.

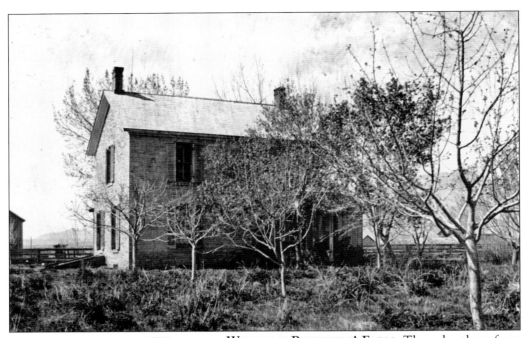

WELLMAN BROTHERS' FARM. Three brothers from Pennsylvania, Henry, Luther, and Sylvanus Wellman, arrived in Boulder in August 1859. They secured 640 acres of land two and one-half miles east of town, where they quickly planted a turnip crop. To their surprise, a grasshopper swarm suddenly blackened the sky and ate everything in sight. The following spring the brothers tested a wheat crop on one acre with great results and expanded to 40 acres the next year. Besides wheat, the brothers grew and sold enough hay, grains, and vegetables to gross $20,000 in one year. Sylvanus (left) married Romelia Towner in 1865, and in 1874, he built a stone house (above) on part of the original land he farmed with his brothers near what is today Arapahoe Avenue and Forty-eighth Street.

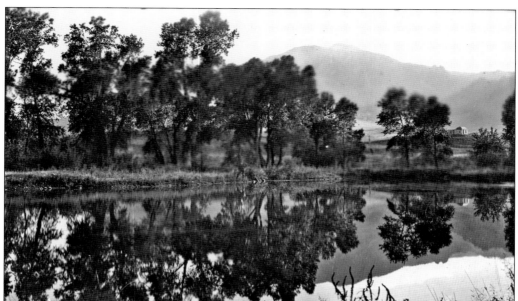

MARINUS "MARINE" G. SMITH.
Born in Oneida County, New York, in 1819, Marinus (right) was a veteran of the Mexican War and the California Gold Rush. Hearing of the gold strikes in the Rockies, Smith arrived in Boulder during the spring of 1859. Instead of prospecting, he made his money in land, an express and mail business, irrigation, and agriculture. He helped build some of Boulder's earliest irrigation ditches and became well known for his vegetable and fruit varieties, the first planted in the area. Created in 1881 by diverting water from Boulder Creek, Smith's Pond (above), located on the south side of Valley Road (Arapahoe Avenue) at Fourteenth Street, irrigated crops during the growing season and supplied ice for the Boulder Brewery in the winter.

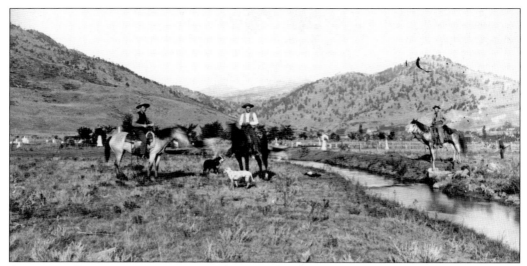

ANDERSON DITCH, C. 1890. Jonas Anderson and Marinus Smith created the Anderson Ditch in 1860 for farm irrigation and water access to households. The ditch runs from the south side of Boulder Creek, through Columbia Cemetery (shown above), and near the University of Colorado campus. In 1884, when Hannah Barker platted the neighborhood of Highland Lawn, deeds included "1/24 of 1 share of the capital stock of the Anderson Ditch Company" for neighborhood water rights.

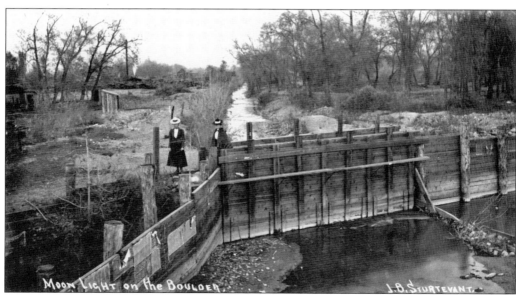

BEASLEY DITCH, AFTER 1894. The 12-mile-long irrigation ditch, later known as the Boulder and White Rock Ditch, began along Boulder Creek in Cigarette Park (Central Park). The Beasley Ditch headgate crumbled when violent floodwaters rushed down Boulder Canyon on May 31, 1894, submerging the low-lying Culver's subdivision in four to six feet of water. Based on the piles of rocks and debris still evident, this is likely the rebuilt headgate.

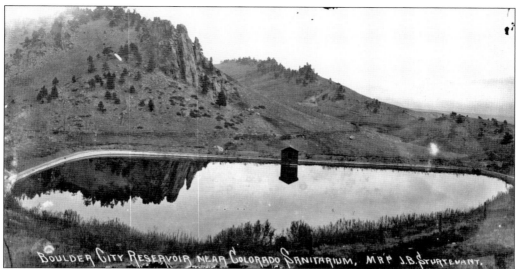

BOULDER CITY RESERVOIR NEAR COLORADO SANITARIUM. MRS J.B. STURTEVANT.

BOULDER CITY RESERVOIR, c. 1893. Despite the numerous irrigation ditches, the community's access to fresh water remained problematic during the 1870s. In 1872, the Boulder Aqueduct Company piped water into the town from Farmer's Ditch. By 1875, the town built a reservoir at the mouth of Boulder Canyon to improve water supply and water pressure. Ephraim Pound (right), a former sheriff and owner of the Colorado House, served as Boulder's first water commissioner and established yearly water rates for homes and businesses. As the mountain mines increased production, the water supply became more polluted with the runoff from the mine dumps. To avoid contaminated water, construction of a new reservoir (above) began in 1890 at the mouth of Sunshine Canyon near the sanitarium.

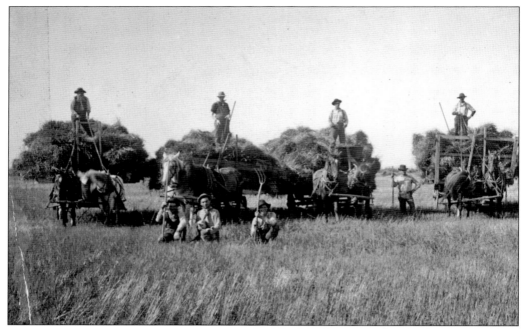

ORCHARD GROVE FRUIT FARM, C. 1900. Joseph Wolff (left) came to Colorado from Stuebenville, Ohio, where he worked at an abolitionist newspaper and under fear of danger from pro-slavery advocates. Arriving in Boulder County around 1861, he continued in journalism by writing for several of the local newspapers. Wolff also purchased a 160-acre farm in 1864 on the east side of Twelfth Street (Broadway) between Forest and Alpine Avenues. He became instrumental in developing vegetable and fruit growing techniques for Boulder's arid climate. Aside from his wheat harvests (above), fruit orchards, vegetable gardens, and dairy cows, Wolff continued his political activity and successfully lobbied for a railroad extension from Erie. He remained on the farm until his death in 1909. His farmhouse, located at 1235 Elder Avenue, still stands. (Left, courtesy of Boulder Genealogical Society.)

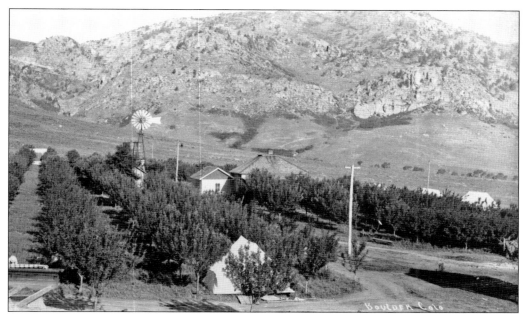

BATCHELDER RANCH, 1898. At the foot of Green Mountain and the Flatirons, this 75-acre farm consisted of alfalfa fields, apple orchards, and a small reservoir. In 1898, the city purchased the ranch to develop the Colorado Chautauqua. During the first year, the farmhouse served as the main office, but its size and layout proved difficult to manage hundreds of visitors. This photograph shows that some visitors decided to pitch tents in the orchards.

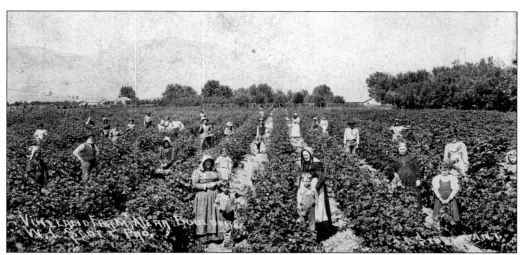

VINELAND FARM, C. 1890. Also known as the Scott Berry Farm, William L. Scott owned this land south of Boulder Creek and east of the expanding University of Colorado. Many of Scott's family members, both young and old, helped in the berry harvest. Vineland Farm later became the Vineland Addition, a residential subdivision. Today the land is part of the University of Colorado campus just south of Folsom Field.

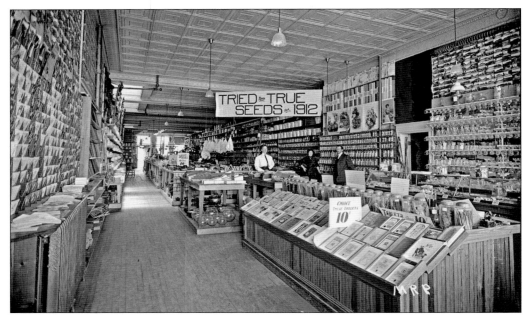

JESSE LONG AND HIS FLOWERS, C. 1915. A tuberculosis sufferer, Jesse D. Long arrived in Boulder in 1900 with the hopes that Colorado's dry air would improve his health. He opened the Noah's Ark Mercantile Company (above) in 1905, and the most popular items became flower seeds. After purchasing three acres at 3240 Broadway, he continued his mail-order seed business while cultivating his flowers at the new Long's Gardens. His seed catalogs reached a yearly circulation of 40,000, inspiring the popularity of gladiolus around the country. Long lived nearly another 50 years and became known throughout America for his irises, peonies, and gladioli. Long's daughter Elizabeth (below) shows off some pansies in the flower gardens at the Broadway farm. Long's Gardens still operates at the same location on Broadway.

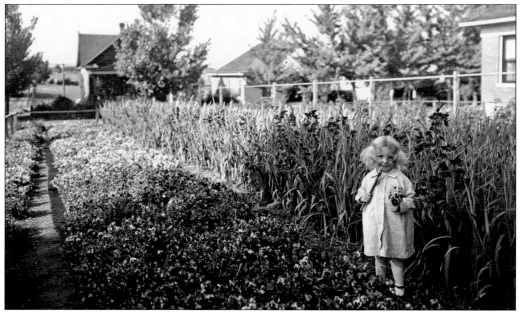

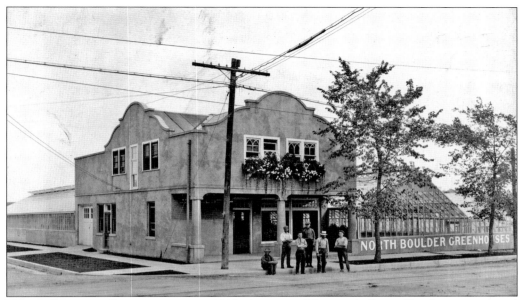

NORTH BOULDER GREENHOUSES, C. 1919. A native of Denmark, Soren Knudsen immigrated to America around 1892, arriving in Boulder in 1899. He operated a vegetable garden before he opened his North Boulder Greenhouse in 1902. Specializing in orchids, Soren and his wife, Ellen, operated the garden, floral shop, and market at 2648 Twelfth Street (Broadway) until his death in 1938.

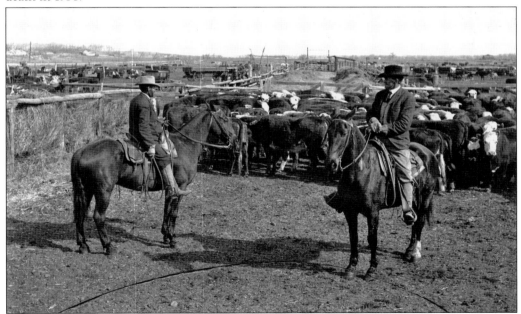

STOCKYARDS, C. 1890. The abundance of prairie grasses and mountain meadows made the Boulder area perfect for cattle ranching. William W. Wolf operated his cattle ranch and slaughter house north of town on Twelfth Street (Broadway) near what is today Iris Avenue, then sold the meat at his butcher shop, located at 1438 Pearl Street. In 1918, Wolf retired and sold his ranch to Boulder County for the development of the County Poor Farm.

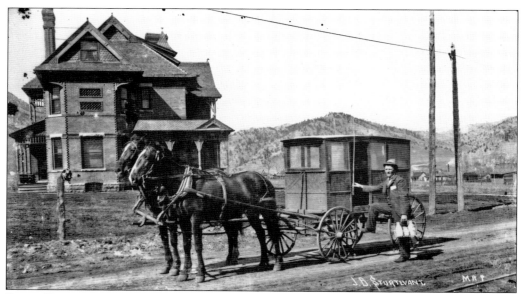

DAIRY FARMING, C. 1900. Dairies first appeared around Boulder during the 1870s. Since they were all well outside the city limits, delivery wagons made daily milk deliveries to homes and markets in town. A Pleasant View Dairy wagon stops in front of the Ira M. DeLong house at 1341 Twelfth Street (Broadway). Located near today's Forty-Seventh Street and Diagonal Highway, the Pleasant View community was the likely location of this dairy farm.

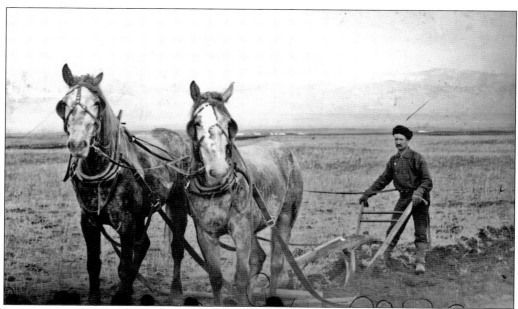

TOUGH PLOWING EAST OF BOULDER, C. 1890. Having well-trained horses and maintaining focus were important for this type of plowing. For the best field results, keeping horses walking in the furrows minimized soil compaction, and keeping an eye out for rocks and other debris allowed the plowman to keep the plow steady and secure in the soil. In Boulder's dry climate, having well-plowed furrows also improved water flow during field irrigation.

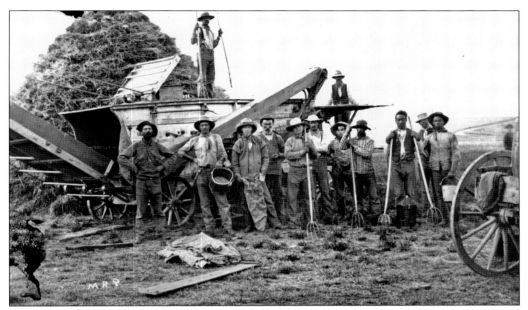

THRESHING WHEAT, C. 1890. Operated by a tractor engine and large leather belts, a mechanical threshing machine dramatically decreased the time it took to process wheat by hand. Workers pitched the cut and dried wheat stalks into the thresher, which separated the grain from the husks and stalks. With the stalks discarded, the wheat was sacked in the field for shipment to a flour mill.

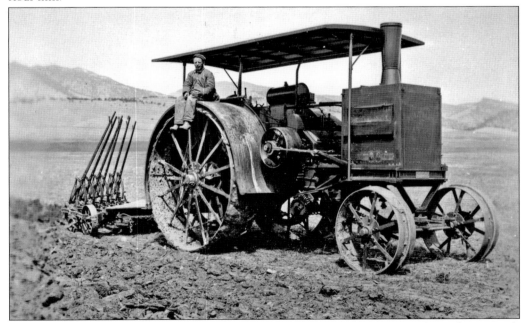

EARLY GASOLINE TRACTOR, C. 1911. This farmer takes a rare moment to rest from plowing with his Aultman-Taylor 30-60 tractor. The massive four-cylinder machine trekked across the fields while a plow hand stood on the back platform, operating the six-lever gang plow. For maximum plowing efficiency, the farmer's helper would rarely raise the levers.

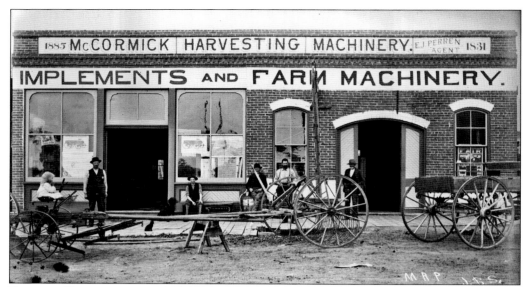

FARMING EQUIPMENT, C. 1886. Edward J. Perrin arrived in Boulder via Denver around 1873 and opened a blacksmith shop. Within about four years, and several business partners later, he expanded his business at 1919–1921 Twelfth Street (Broadway) and began building and repairing wagons, in addition to selling farm equipment and agricultural machinery.

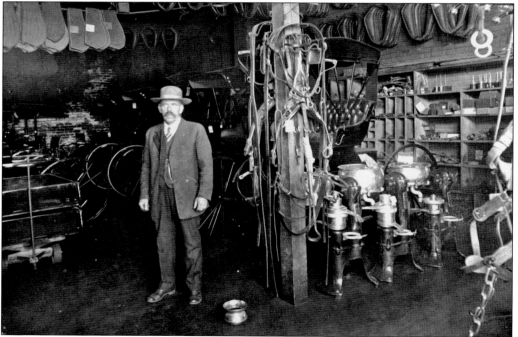

SIMPSON "SAM" WYLAM, C. 1901. Around 1868, at about the age of seven, Wylam and his family arrived in Boulder. His father worked a farm south of Boulder and later homesteaded an 80-acre farm near what is today Broomfield. Early in his career, Wylam worked as a blacksmith, and for several years he partnered with Jacob Faus. About 1901, Wylam opened a farm and harvesting machinery store at 1903 Twelfth Street (Broadway).

Four

EARLY ENTREPRENEURS

While most who came to the Boulder area took up mining, many men pursued non-mining professions and opened shops on or near Pearl Street, Boulder's version of Main Street. Named during Boulder's first survey in 1859, legends claim Pearl was the name of a pioneer's wife or mother. No solid evidence has yet been found, so its origin remains a mystery.

Businesses came and went as economic trends shifted. During the early decades, Boulder was particularly sensitive to the ebb and flow of mining interests. Businesses that remained stable were small industries essential to Boulder's operation and development. With the silver strike in Caribou and news of the railroad's arrival, the 1870s brought renewed hope to Boulder's businesses. The railroad connection suddenly opened new marketplaces for broader economic potential.

Aside from the small industries assisting in Boulder's growth, such as brickyards, foundries, and sawmills, residents had little interest in bringing big industry to the town. Throughout the decades, Boulder supported a range of businesses that filled nearly all the needs of daily life.

Changes in society altered the outlook of some businesses. As Boulder moved away from horse-based transportation, the need for liveries and blacksmiths lessened, causing those industries to disappear. With the increase of social pressures from temperance groups, brewery and saloon owners found it difficult to survive, ultimately shutting down because of statewide Prohibition. Despite the decline of certain industries, new ones emerge, continuing to bring economic diversity to Boulder.

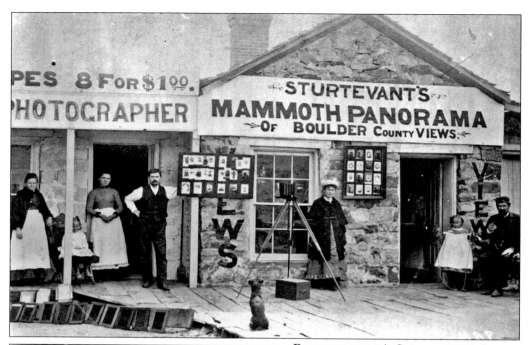

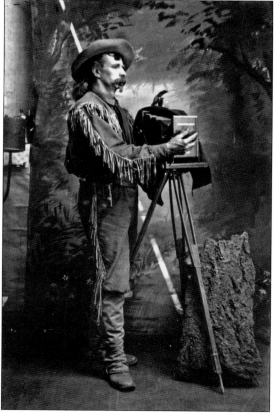

PHOTOGRAPHER'S STUDIO, 1885. By trade an artist, painter, grainer, and wallpaper hanger, Joseph B. Sturtevant (left) began taking photographs in 1884 and quickly became one of Boulder's most prolific early photographers. For nearly three decades, "Rocky Mountain Joe" extensively documented the people, businesses, activities, and scenery of Boulder and the surrounding communities. Throughout the years, Sturtevant occupied several studio locations around town, including his second studio (above), shown at 1122–1124 Pearl Street. Born in Massachusetts but growing up in Wisconsin and Minnesota, Sturtevant spoke of an early life full of adventure, Civil War battles, and Native American fighting. While there is no current proof of his claims, his stories certainly did not hurt his photography career as he became the popular buck-skinned storyteller, tourist guide, and Chautauqua's official photographer.

CHARLES SNOW'S STUDIO, C. 1910. A Wisconsin native, Charles F. Snow came to Boulder in 1908 at the age of 22. Looking for work as a freelance photographer, Snow quickly contracted with Charles Gosha in his studio at 2028 Fourteenth Street. The following year, Snow purchased Gosha's studio and remained at the Fourteenth Street location for 25 years. Snow continued his prolific and successful photography career until his death in 1964.

LAWRENCE BASS, C. 1890. Lawrence and his family arrived from Missouri about 1880 when he was 10 years old. As a teenager, Bass followed his photography interests and worked as a photographer while still in school. He photographed people and businesses, and many of the 1894 flood landscape photographs are his. Bass's interests gradually turned to law enforcement, and he served for many years as Boulder's town marshal.

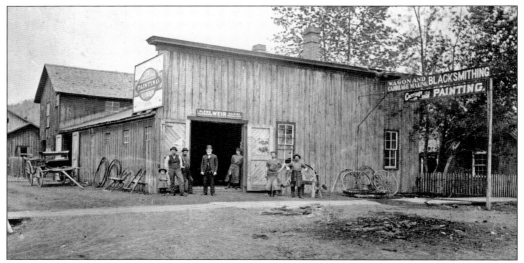

BEN WILLIAMS'S BLACKSMITH AND PAINT SHOP, C. 1870S. The Boston-born Benjamin Williams arrived in Boulder in September 1868. He constructed his 40-by-40-foot shop on Twelfth Street (Broadway) just north of Pearl Street and became the first to manufacture carriages and wagons in Boulder. Williams built his wagons strong to handle the abuse from the mountain roads, and his customers believed his wagons were a better quality than Eastern-made vehicles.

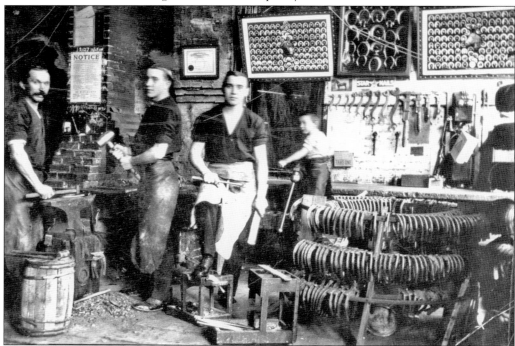

INSIDE A BLACKSMITH'S SHOP, 1900. Born in Germany, Jacob Faus arrived in Boulder in the 1870s and began a blacksmithing apprenticeship with Ben Williams. By 1892, he had partnered with Sam Wyman, and they opened a shop at Twelfth (Broadway) and Front (Walnut) Streets. The two specialized in horseshoes, made evident in this photograph. Here Jacob stands on the extreme left, with his sons (from left to right) Jack (Jacob Jr.), Ben, and young Robert.

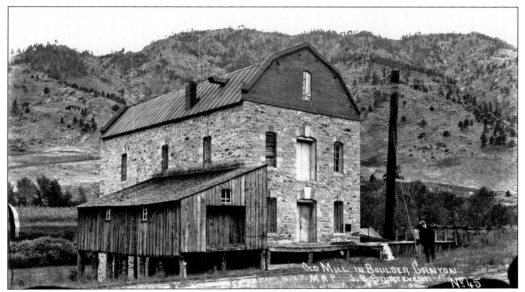

COLORADO STATE MILLS, C. 1895. Andrew Douty first built a flour mill in 1866 at the mouth of Boulder Canyon and Pearl Street. First named the Red Rock Mill, its name changed to the Colorado State Mills in 1876 when Abram and Ella Yount took over its operation. After her husband died, Ella rebuilt the mill in stone and operated it until 1883. After two fires, one in 1899 and another in 1905, the owners never rebuilt.

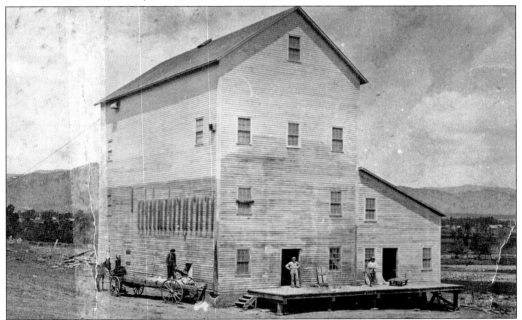

BOULDER CITY MILLS, BEFORE 1889. Built along Boulder Creek just outside the city limits at Twenty-third Street and University Avenue, brothers Jay and DeKalb Sternberg owned this flour mill. With this first mill, the brothers quickly gained a reputation for high-quality flour, many believing it was better than the high-grade flour shipped from the East. The wood building burned in 1889, and the company rebuilt at Eleventh and Front (Walnut) Streets.

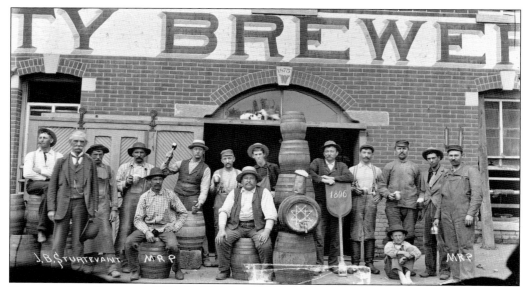

BOULDER CITY BREWERY, 1896. In 1875, brothers-in-law Frank Weisenhorn and Charles Voegtle arrived in Boulder with a goal to brew beer. The following year, their brewery on Tenth Street, between Valley Road (Arapahoe Avenue) and Marine Street, produced its first kegs. The brewery gained an excellent reputation for its lager and bock beers, making deliveries to saloons, hotels, and even to local homes.

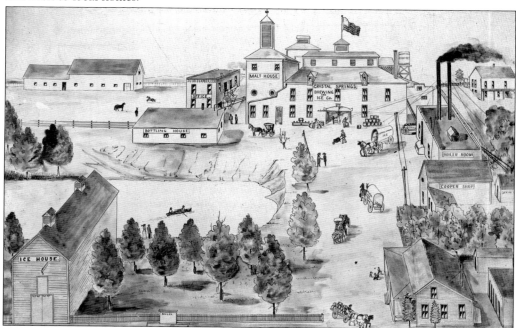

NEW BREWERY, C. 1900. This Joseph Sturtevant illustration depicts the Crystal City Brewing and Ice Company complex. George Fonda, Isaac Berlin, and Andrew Macky purchased the Boulder City Brewery property in a foreclosure sale in 1897. City directories indicate the business remained operational until about 1911. A fire in 1921 destroyed the complex except for the company house, shown at the lower right corner. The house still stands at 952 Arapahoe Avenue.

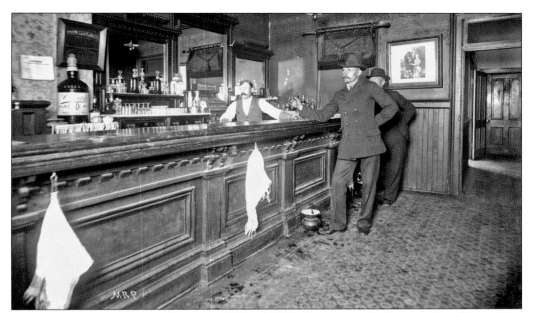

WERLEY'S SALOON, C. 1895. Between 1883 and 1888 the number of saloons declined from 28 to 7 as the annual liquor license fees grew from $240 to $1,000. Peter J. Werley's saloon, located at 1314 Pearl Street, was one of seven saloons in town around the time of this photograph. Werley operated a saloon in Leadville prior to his arrival in Boulder in the early 1880s.

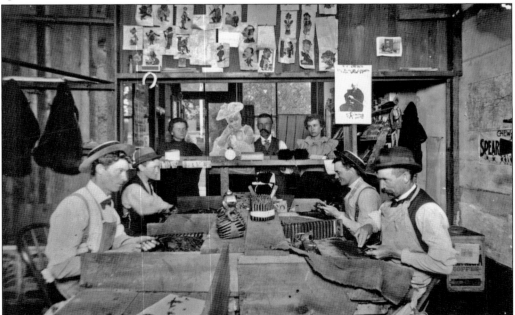

ROLLING CIGARS, C. 1896. Cigar makers in Boulder had little competition, with only a few cigar manufacturers appearing in the city directories throughout the decades. While demands for cigars were high, prices were low, possibly making profits difficult for small operations. This photograph is possibly the interior of the Nox-All Cigar Company, located at 1326 Pearl Street. Benjamin Price produced the only other cigars in 1896, but by 1898, both businesses had closed.

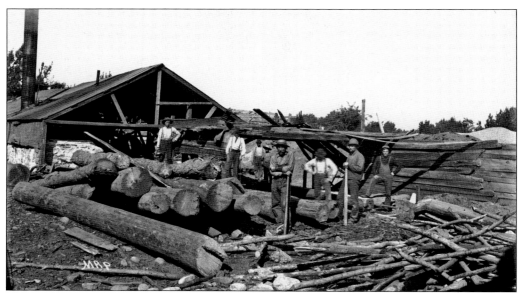

LOUNSBERRY SAWMILL, C. 1885. The constant need and demand for lumber during Boulder's development kept loggers, sawmills, and planing mills in continual business. Requiring a great amount of space for the mill's operation, Frank Lounsberry located his sawmill close to the city limits near Sixth Street between Water (Canyon) and Front (Walnut) Streets.

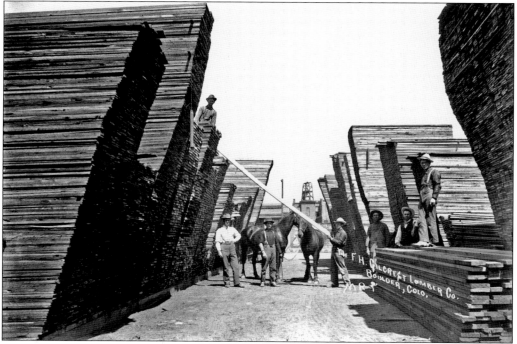

LUMBERYARDS, 1903. Used in nearly every aspect of daily life, wood created houses, furniture, wagons, sidewalks, railroad beds, and supported mine tunnels. Mountains of lumber loom over patrons as workers lower the boards at the F. H. Gilcrest Lumber Company on the south side of the 1000 block of Front (Walnut) Street.

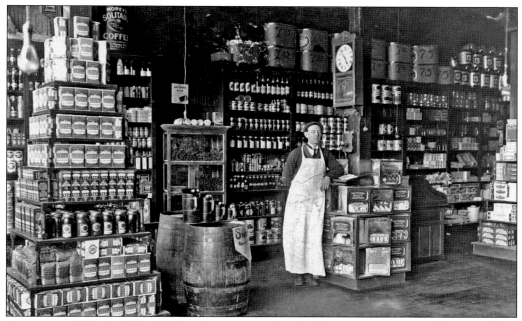

RACKET, C. 1913. In 1902, J. W. Brady opened the Racket Grocery store in a small brick building on the southeast corner of Seventh and Pearl Streets. He remained at this location for many years, renaming the store Brady's around 1913. Herb Hocking (shown above) did not work at the grocery, but he did purchase the meat market next door around 1913. Some of the products include National Biscuit Company crackers and Log Cabin syrup.

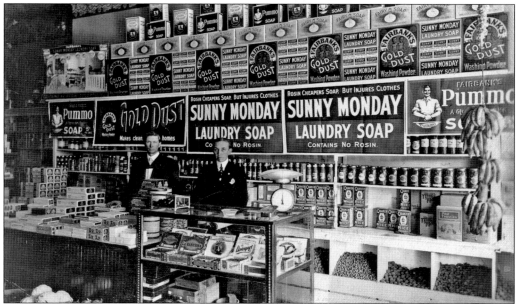

STRAWN AND ESGAR GROCERY STORE, C. 1903. As early as 1901, T. L. Strawn and Frank T. Esgar (at left) owned the store located at 2047 Broadway in the Willard Building. By 1905, Esgar had left the business, and Strawn had teamed up with Guy Adams. Some of the products include Quaker Puffed Wheat cereal, Post Toasties cereal, Zu Zu Ginger Snaps, and Graham Crackers.

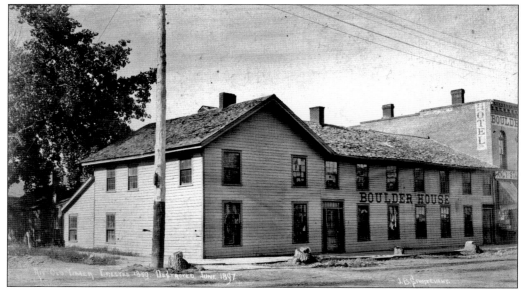

BOULDER HOUSE HOTEL, C. 1894. Built in 1859, Boulder's first hotel began as a grocery and supply store in a small log cabin on the northeast corner of Eleventh and Pearl Streets. A two-story addition created boarding rooms, a dance hall, and a dining room, while the log cabin became the kitchen. In 1897, after nearly 40 years in operation, the newly constructed Cheney Block (later Buckingham Block) replaced this old hotel.

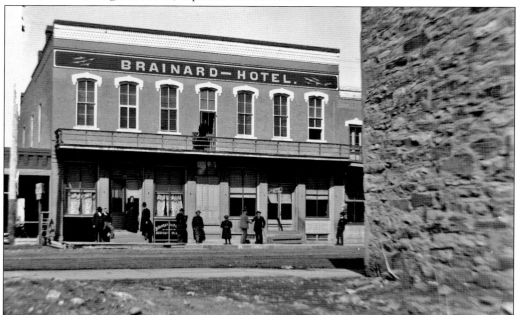

BRAINARD HOTEL, C. 1895. Anthony Arnett constructed this building in 1874 across the street from the *Daily Camera* offices at 1025 Pearl Street. Throughout the decades, the hotel went by the Sherman House, Brainard Hotel, Stillman Hotel, and then the Arnett Hotel in 1913. During its time as the Brainard, many celebrities visited here, including former U.S. president Ulysses S. Grant and P. T. Barnum. The building collapsed during a heavy snowstorm in 1978.

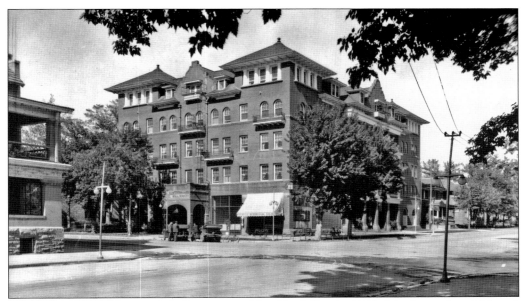

HOTEL BOULDERADO, C. 1919. Opening on New Year's Day in 1909, this elegant hotel (above) received its name by combining Boulder and Colorado, assuring no visitor forgot where he had stayed. Designed by William Redding and Son, the Boulderado offered comfort and luxury rivaling any urban hotel. Its spacious lobby displayed an impressive cantilevered staircase and stained-glass canopy ceiling. Rooms cost $1 to $2.50 per night, and guests enjoyed meals in the handsome dining room (below). This grand hotel is still in operation at Thirteenth and Spruce Streets.

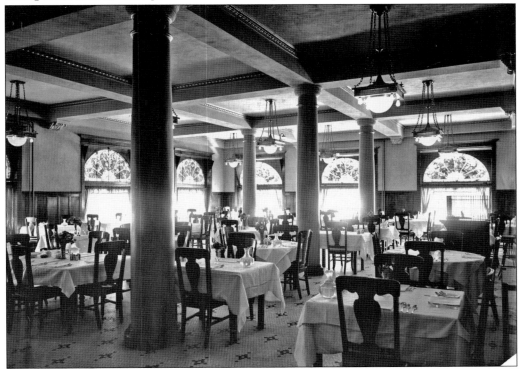

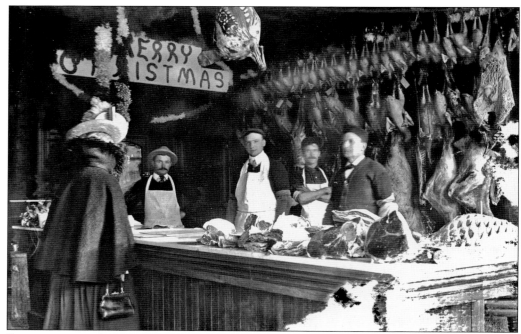

SHOPPING FOR A CHRISTMAS TURKEY, C. 1901. This elegantly attired woman places a holiday order at W. W. Wolf's Meat Market, located at 2054 Broadway. Typical of other turn-of-the-20th-century butcher shops, Wolf's freshly dressed poultry hung in the store, along with his specialty salt-cured beef and pork. Marble counters kept meats cool and likely made cleanup easier and more sanitary.

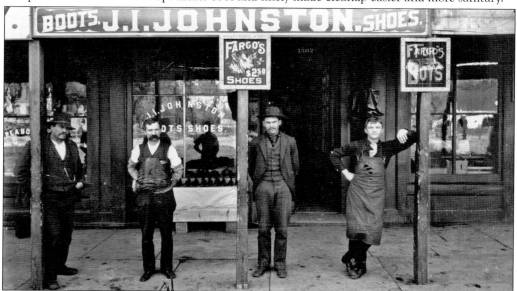

JOHNSTON'S SHOE STORE, C. 1895. William Johnston moved from Caribou to Boulder in 1876 and worked from a small log cabin on the 1100 block of Pearl Street. In 1878, his brother James I. Johnston joined him. They set up a shoe store at 1223 Pearl Street before moving to 1302 Pearl Street about 1895. Popular with the miners, the Johnstons' store became a regular spot for socializing and lively discussions.

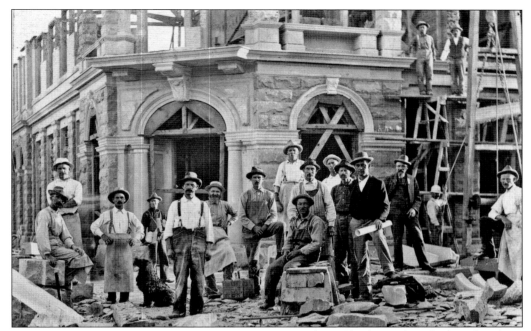

NATIONAL STATE BANK CONSTRUCTION, 1899. Brothers Charles and Walter Buckingham established Boulder's second bank in 1874. After the bank outgrew two earlier buildings, the brothers decided to build on the southwest corner of Thirteenth and Pearl Streets. Until construction was finished, the bank operated from the Masonic Temple building located one block to the east. The bank reopened at its new location on January 1, 1900.

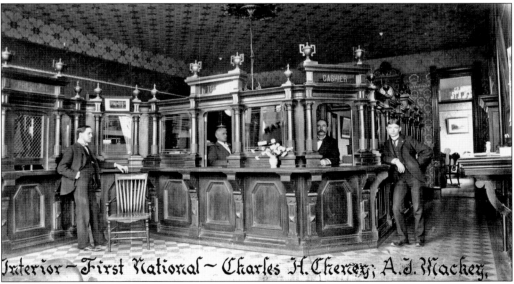

Interior ~ First National ~ Charles H. Cheney; A. J. Mackey,

FIRST NATIONAL BANK INTERIOR, 1898. Established by Lewis Cheney and Israel M. Smith in 1877, the First National Bank stood on the southeast corner of Twelfth (Broadway) and Pearl Streets for most of its existence. In 1882, the building was overhauled, producing this decorative lobby and cashier windows. The men (from left to right) are Lewis Cheney, Andrew J. Macky, William H. Allison, and Charles Wise.

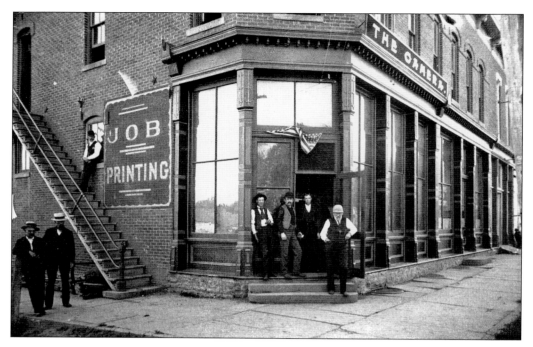

DAILY CAMERA NEWSPAPER, C. 1892. On September 17, 1890, the first weekly issue of the *Camera* circulated around town. It was renamed the *Daily Camera* the following year when the newspaper went to a daily format. Staff members, from left to right in doorway, Billy Green, Charles Butsch, unidentified, and Valentine Butsch (with the beard) take a break in front of the *Camera*'s office, located at 1048 Pearl Street (above). In addition to the newspaper, the company printed posters, advertisements, and artistic prints, which hung on the walls of the typesetting and pressroom (below). This building remained at the corner of Eleventh and Pearl Streets until its demolition in 1963 to make room for the new *Daily Camera* complex that stands at the same location today.

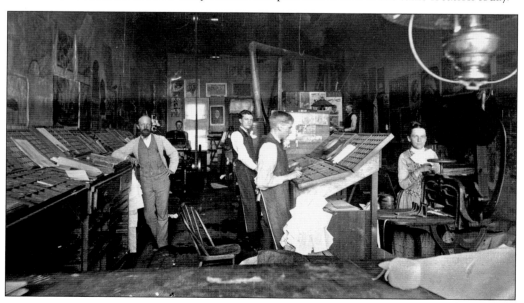

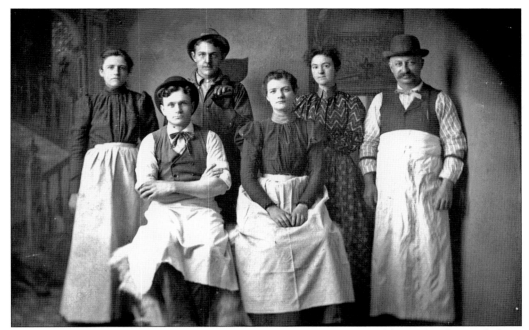

LAUNDRY BUSINESS, C. 1900. Owned by Robert Emmett Arnett and his wife, Ida, until about 1900, the Elite Steam Laundry was Boulder's first steam laundry for at least a decade, located at Twelfth (Broadway) and Front (Walnut) Streets. City directories show Arnett operating the Model Steam Laundry at the same location from 1900 until 1903, while the Elite Laundry relocated to 1933 Eleventh Street under new ownership. Two of the identified Model Laundry workers (above) are believed to be "Curly" Goddard and Ella Wold. Based on the shape and height of the work room windows, the laundry interior (below) is likely the Elite Steam Laundry after it moved to the Eleventh Street location.

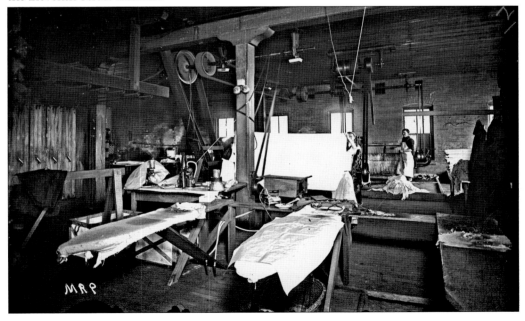

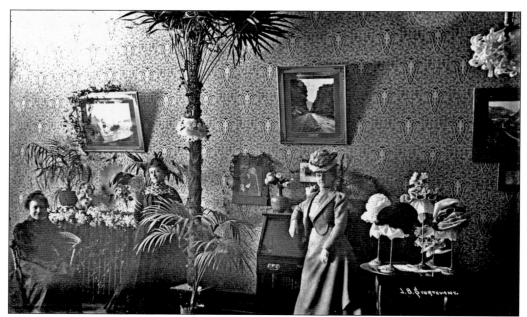

WOMEN'S OCCUPATIONS, C. 1900. Boulder's first settlers were men, but the women were not far behind. The 1860 census lists 58 adult women in the Boulder area and 30 in Gold Hill. They appear to have been mostly wives and daughters. In addition to homemaking and child rearing, women contributed to Boulder's development by running boardinghouses, cooking, teaching, and working as clerks, doctors, typesetters, and even barbers. The most common occupations for women were as millinery workers and seamstresses (below). Located at 1109 Pearl Street, the proprietor of Boulder Millinery Parlors (above), Laura Craig, created quite an elaborate decor to compliment her fancy hats.

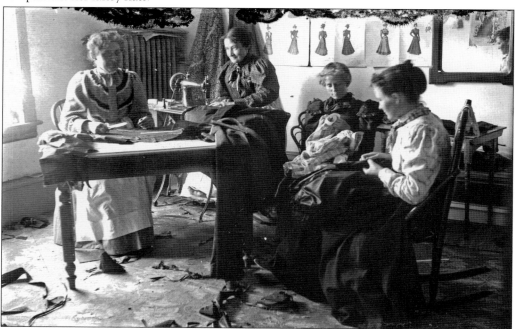

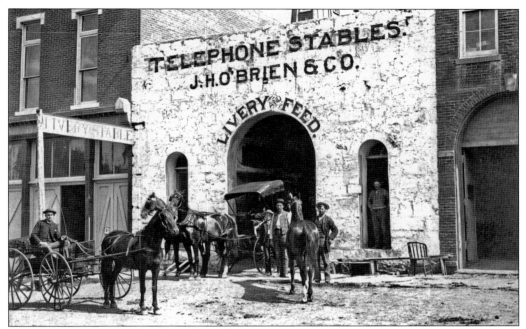

MANAGING THE HORSES, C. 1885. Public liveries offered services such as caring for patrons' horses and providing visitors with horse-and-carriage rentals, while hotels included private livery services for its guests. In 1883, J. H. O'Brien changed the name of his stable to the Telephone Stables since it became the first in town with a telephone.

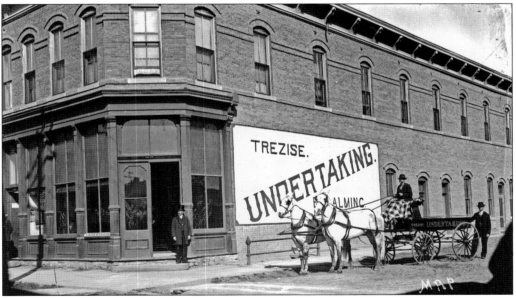

BUSINESS OF DEATH, C. 1898. John G. Trezise (in doorway) arrived in Boulder around 1876 and set up his shop at Eleventh and Pearl Streets. Respected by his fellow citizens, his obituary fondly recalls him as "a funeral director from head to foot. He looked it and acted the part with a style and a delicacy that set him apart from other men." After his death in 1918, his wife, Georgina, managed the business.

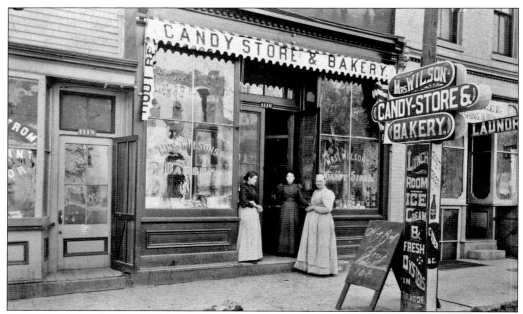

MRS. WILSON'S CANDY STORE, C. 1900. Elizabeth Wilson not only sold candy, baked goods, and ice cream at her 1116 Pearl Street shop, but according to city directories, she also operated a lunch and coffee parlor, sold cigars, and served alcohol-free "temperance drinks" of all kinds.

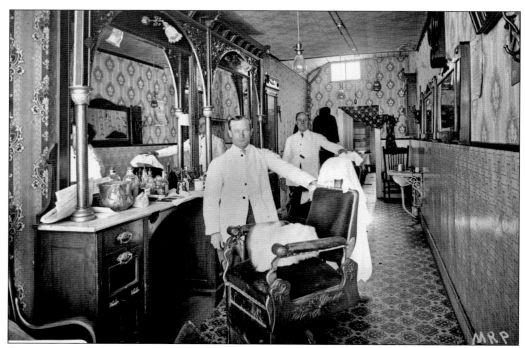

SHAVE AND A HAIRCUT, C. 1910. The fine wood cabinetry, elaborately designed barber chairs, and decor suggest this small barbershop might have been located in the Hotel Boulderado in the 1910s.

Five

PEOPLE, ACTIVITIES, AND ORGANIZATIONS

The promise of gold attracted people from all walks of life. The early years in Boulder were a mix of people and cultures from around the country and the world. Examining the contributions made by immigrants, African Americans, and women is important in understanding the community as a whole.

Most immigrants came as miners, but some established hotels, blacksmith shops, and breweries. In order to keep some cultural traditions alive, immigrants often socialized together to keep a connection with the home country.

Boulder's African American community remained small over the decades. Some black families lived around town, but by the turn of the 20th century, most lived on Water (Canyon) or Goss Streets between Nineteenth and Twenty-second Streets. Despite the racism this small group faced, Boulder's African Americans contributed to the community through food, music, and their church.

While some women worked or owned their own businesses, many of Boulder's women remained in the home and got involved in church groups, women's clubs, and literary societies. As social reform pressures increased, women became more political by rallying for the end to prostitution and the consumption of alcohol.

As Boulder grew and its population diversified, churches and other organizations allowed residents to socialize with people of similar beliefs or interests. Many fraternal groups organized based on veteran status or by occupation. These groups often included women's auxiliaries that planned fund-raisers, social outings, and activities.

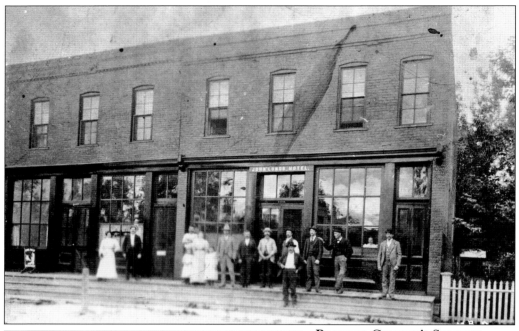

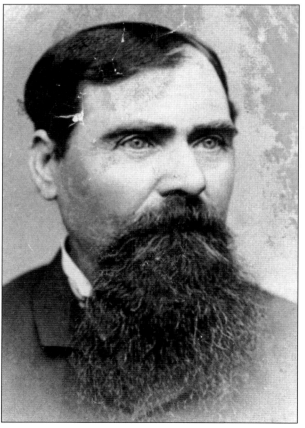

BOULDER COUNTY'S SWEDISH POPULATION. The first Swedes in the county came around 1870 and settled southwest of Longmont, forming the town of Ryssby. As more immigrants continued arriving in Boulder, Swedish-born John Lund (left) and his wife, Anna, built a hotel and saloon on the 1900 block of Pearl Street. The John Lund Hotel (above) became a haven where recent arrivals from Sweden could stay and reunite with family and friends or meet future employers. The establishment became quite successful thanks to the friendly atmosphere and entertainment, but it was Anna's exceptional cooking that became especially popular. In 1900, John was shot after a misunderstanding, and survived several years despite being significantly paralyzed. He died in 1907, and his wife operated the hotel until 1915. The building still stands. (Left, courtesy of Boulder Genealogical Society.)

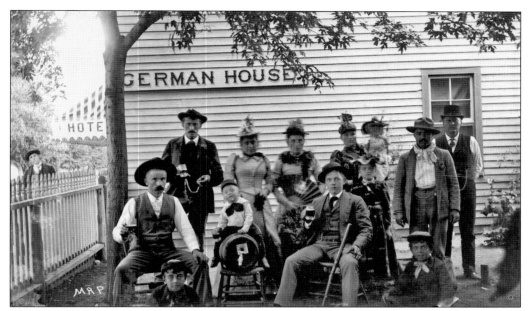

GERMAN HOUSE, C. 1890. Frank Heizelman built this hotel in 1878 at the corner of Eighth and Pearl Streets. A popular spot for Boulder's German-born residents with its tree-filled *bier garten*, it became a relaxing place to enjoy a glass of beer, socialize, and speak German. Heizelman served as one of the founding members of the Boulder *Turnverein* Society in 1883, a club that promoted exercise, learning, and German culture.

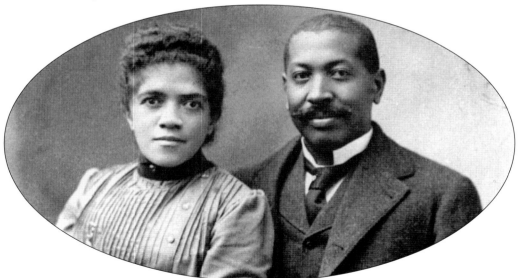

OLIVER T. AND SADIE JACKSON, BEFORE 1903. A caterer from Ohio, Jackson first arrived in Colorado in 1887 and then Boulder in 1894. Quite an entrepreneur, he ran a restaurant, the Stillman Hotel, established Jackson's Resort near what is today Arapahoe Avenue and Fifty-fifth Street, managed Chautauqua's Dining Hall, served as a messenger for several Colorado governors, and founded the African American farming colony of Dearfield near Greeley. (Courtesy Boulder Genealogical Society.)

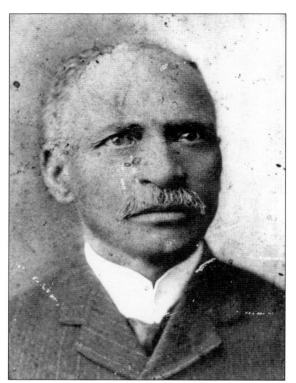

JUNIUS R. LEWIS, C. 1916. Born a slave in Mississippi in 1842, Lewis ran away at the age of 20, only to be captured and made a servant in the Confederate army. After the war, Lewis traveled west, arriving in Boulder around 1896, when he bought into the Golden Chest Mining Company. He continued mining until the age of 79 and then modestly retired to Denver in 1921. (Courtesy Carnegie Branch Library for Local History.)

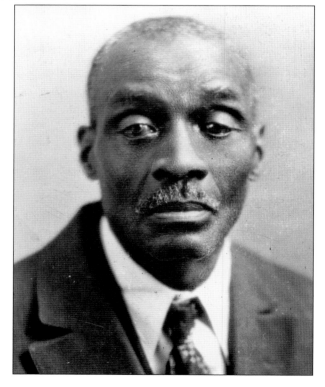

HENRY STEVENS. Born in Missouri as the son of freed slaves, Henry traveled to Boulder in 1879 with photographer J. E. Streeter. Working as an assistant, Stevens became skilled in photography and advertising. After Streeter died, Stevens worked in several restaurants and as a janitor for the First National Bank. A respected man, he retired from the bank after 50 years of service. (Courtesy Carnegie Branch Library for Local History.)

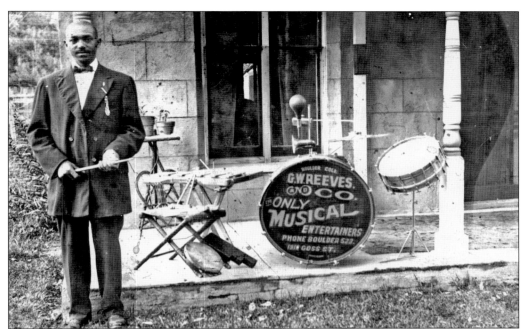

MUSIC MAKERS, C. 1905. Born into a musical family, George Morrison (right) excelled at the violin. When he and his brother Lee moved to Boulder in 1900, Morrison took odd jobs around town to pay for his own music lessons. Their small Morrison Brothers String Band entertained people all around Boulder and in the mining camps. Morrison moved to Denver in 1911 and later gained local and national fame as a jazz musician. George Reeves (above) arrived in Boulder in 1903 and played drums with Morrison's band in addition to being his brother-in-law. Reeves made a living playing in a band, working as a laborer, and later running a shoe-shine parlor on Twelfth Street (Broadway). The house located at 1921 Goss Street, where he lived for more than 30 years, still stands. (Above, courtesy Carnegie Branch Library for Local History.)

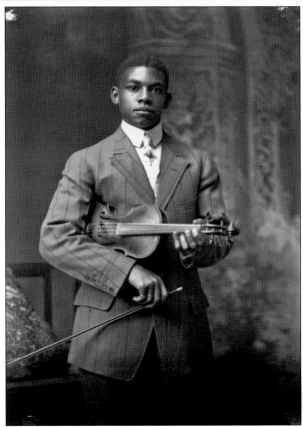

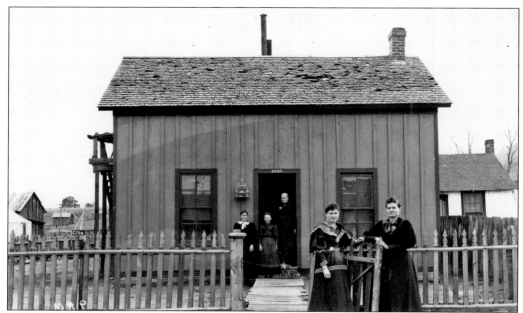

RED LIGHT DISTRICT, C. 1900. An infamous Boulder prostitute, Marietta Kingsley purchased this house for her bordello at 1036 Water (Canyon) Street in 1893, near what is now the Boulder Public Library. While this area was a popular red light district during the 1890s, it is not known if prostitution continued here after Kingsley rented out the house. Two women in this photograph are believed to be Rosaltha Miller, a landlady, and her daughter Ruby.

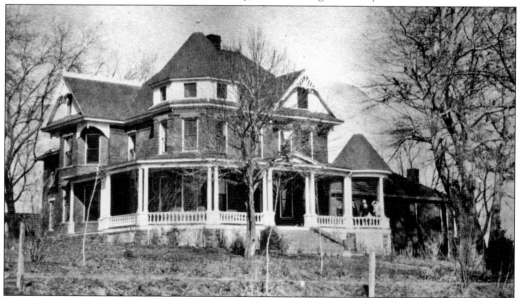

BOULDER COUNTY POOR FARM, C. 1918. In the 1870s, Boulder County began caring for its poor and mentally ill by providing free rooms, but no one wanted the facility in their neighborhood. The "poor house" relocated often throughout the decades, and in 1902, the county purchased the old Chambers homestead north of Valmont on Sixty-third Street. The institution remained here until 1918. (Courtesy Carnegie Branch Library for Local History.)

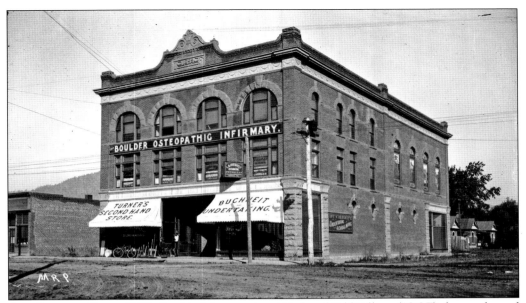

ODD FELLOWS HALL, 1902. Boulder's International Order of Odd Fellows (IOOF) chapter formed in 1869. Some of the most significant functions of this fraternal organization were essentially early forms of insurance. Members cared for others in times of need or for those who were ill, they performed funeral services, and they cared for members' widows and orphans. Constructed in 1899, the IOOF hall still stands on the northwest corner of Sixteenth and Pearl Streets.

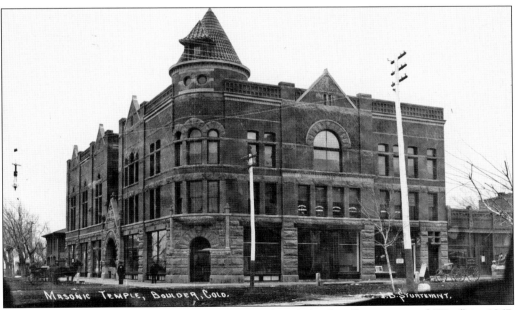

MASONIC TEMPLE, C. 1896. Originally organized in Columbia (later renamed Ward) in 1867, the Knights Templar, Columbia Lodge No. 14 of the Ancient Free and Accepted Masons moved their lodge to Boulder the following year. In 1895, the lodge built a new Masonic Temple at the southwest corner of Fourteenth and Pearl Streets. The lodge remained active, and businesses lined the building's street level until a fire in 1945 completely destroyed the structure.

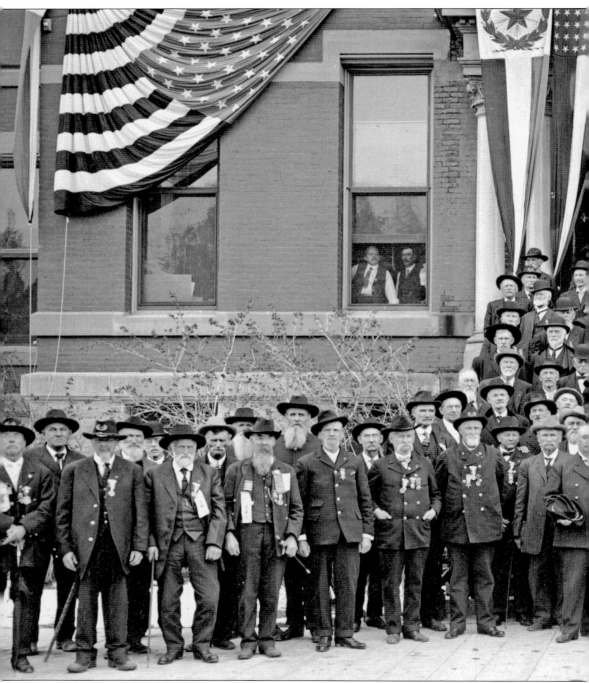

GRAND ARMY OF THE REPUBLIC, C. 1910S. By 1881, hundreds of Civil War soldiers had made Boulder County their home. Any honorably discharged soldier from the Union army was eligible for membership into the Grand Army of the Republic (GAR). The group's goals included reuniting those "who espoused a common cause, to relieve distress among its members, and to care more tenderly for the widows and children of deceased comrades." On April 19, 1881, members organized

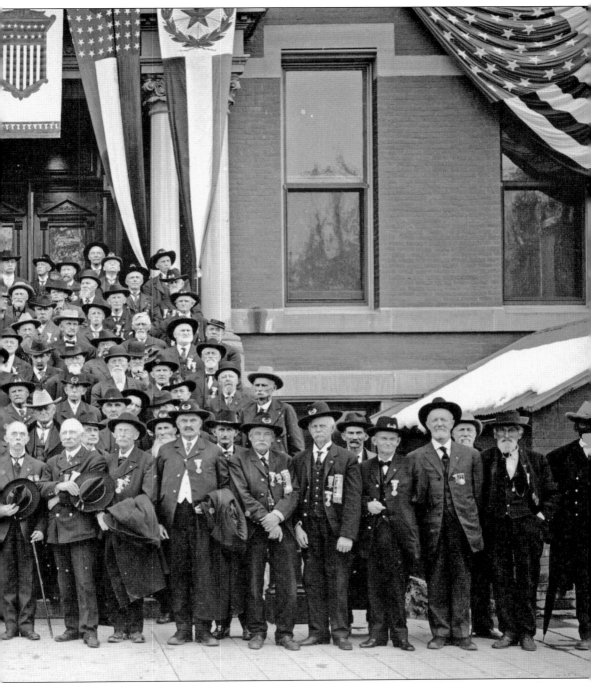

Boulder's local chapter, naming it Nathaniel Lyon Post No. 13 (later No. 5). Posts customarily received names of fallen comrades or important battles. Boulder's post also welcomed two African American Union veterans, Oscar White (not shown) and James Hall (far right) The organization dissolved in the 1940s because membership became too small. The last member of the post, Robert T. Bryan, died in 1949.

HANNAH CONNELL BARKER. The Irish-born Connell arrived in Boulder during the 1860s and worked as a teacher until she married Ezra Barker Jr. After Ezra died in 1883, Hannah focused on the community. She platted the Highland Subdivision in 1884, organized the women-owned Boulder Creamery Company in 1887, and sold land to develop the Barker Dam. She died at the age of 74 during the 1918 influenza epidemic but passed away of arteriosclerosis, not influenza.

MARY RIPPON, 1906. The first female professor at the University of Colorado in 1878, Mary taught German and French, and later chaired the German Language and Literature Department. Because female teachers could not marry or have children, Mary's dedication to her 31-year career compelled her to keep silent about her marriage and daughter. It was a secret she took to the grave. Her "spinster" facade was finally cracked in 1976 when Mary's grandson, Wilfred Rieder, disclosed the family secret.

MARTHA DARTT MAXWELL, 1876. As a young woman, Martha acquired a fascination for collecting plants and wildlife for artistic and scientific purposes. A self-taught naturalist and skilled taxidermist, she opened her own museum in 1874, becoming well known for the realistic and dynamic arrangements of her exhibits. The museum moved to Denver, and in 1876, she represented Colorado at the Philadelphia Exposition. Her work heavily influenced future museum exhibits and dioramas.

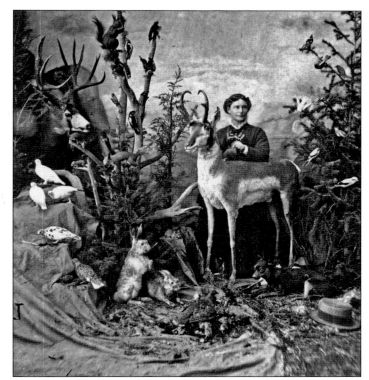

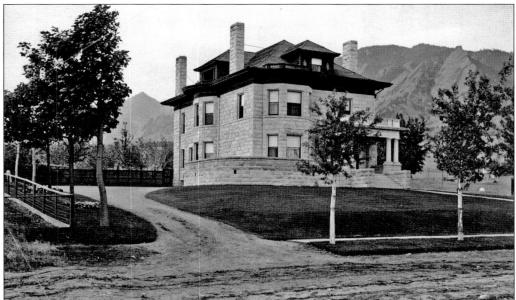

HARBECK HOUSE, C. 1900. Built as a summer house by Kate and John Harbeck, the wealthy New Yorkers led a private life at their home located at 1206 Euclid Avenue (today the Boulder History Museum). Kate loved animals, holding elaborate funerals for her dogs in the backyard. In 1930, upon her death, $50,000 of her multimillion dollar estate went to establish the Boulder Humane Society. Her dogs were later reinterred at the Humane Society.

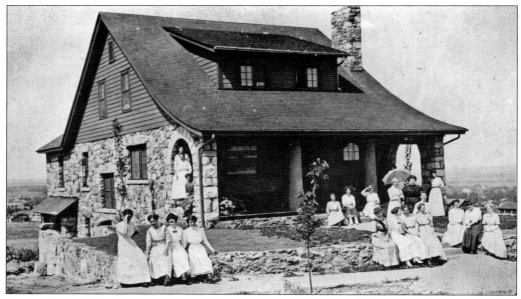

BLUEBIRD COTTAGE, 1912. While teaching art at Chautauqua, Jean Sherwood (left) fell in love with Boulder's surroundings. As a member of the Holiday House Association of Chicago, Sherwood established the Bluebird Cottage in 1911 as a vacation retreat for single professional women from the Chicago area. A lifetime membership cost $10, and a young lady could spend two weeks every summer in the stone cottage located at 1215 Baseline Road near Chautauqua (above). The companion Bluebird Lodge in Gold Hill provided a more rustic Colorado experience with its main log house and cabins. In 1923, Sherwood founded the Boulder Arts Association and then the Boulder Artist Guild three years later. (Left, courtesy Carnegie Branch Library for Local History.)

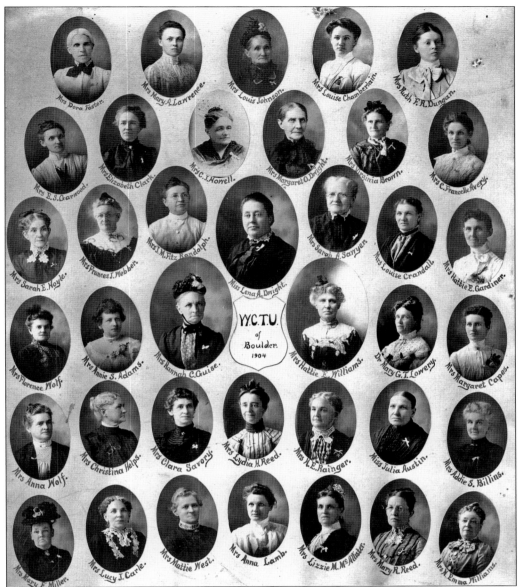

WOMEN'S CHRISTIAN TEMPERANCE UNION, 1904. The first meeting of the Women's Christian Temperance Union (WCTU), organized in 1881, brought together more than 100 members with the goal of ridding alcohol from society. Historian Elliot West discusses how temperance reform was a symbolic fight against what many saw as a threat to traditional values. Saloons represented lewd behavior, absent fathers, indulgence, and, ultimately, society's downfall resulting from urbanization, industrialization, and new waves of non-Protestant immigration. The WCTU won its fight when Boulder citizens voted to close the city's saloons in 1907. Statewide alcohol Prohibition took effect in 1916, and national Prohibition followed close behind in 1920. It took 60 years before Boulder finally lifted its alcohol ban and became a "wet" city again.

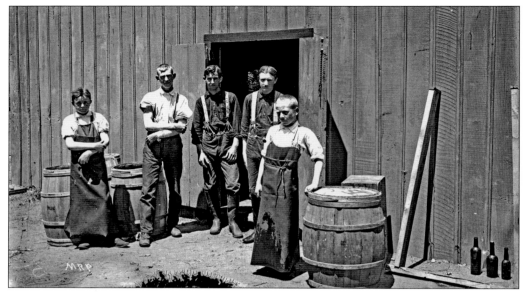

YOUNG BREWERY WORKERS, C. 1890. Child labor laws during the late 19th century varied from state to state, and many young children worked grueling hours in urban factories. Child workers in smaller communities and rural areas more likely worked in the family business or on the family farm. These young men and boys worked at the Boulder City Brewery and could possibly be the sons of the owners, Frank Weisenhorn and Charles Voegtle.

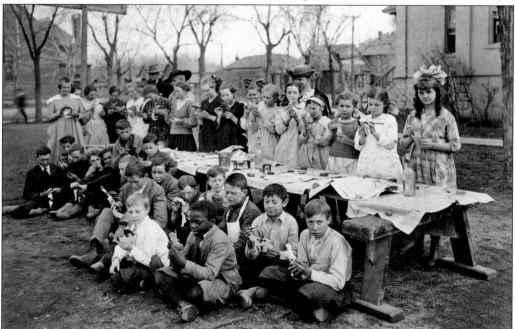

RED CROSS TOY MAKERS, 1918. Central School students painted toys for European children to help with the relief efforts during World War I. Boulder's children participated in many war-related activities through their schools, including knitting sweaters, blankets, and socks for soldiers. The children also planted Victory Gardens in small lots along the irrigation ditches.

FIRST METHODIST CHURCH, 1892. Rev. Jacob Adriance organized the church in November 1859 with six parishioners. The church first held services in private homes and then moved to the public schoolhouse and later to the Congregational Church. The first church was constructed in 1872 on the corner of Fourteenth and Spruce Streets, but as the congregation grew, a second church was built on the same site in 1892 and still stands.

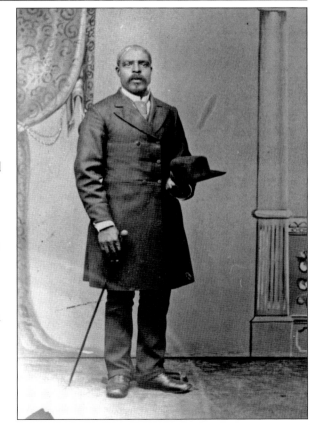

REV. JAMES CLAY. Before 1884, Boulder's African American residents worshiped in the local white churches. After informally meeting on their own for more than a year, about one dozen charter members built the Allen Chapel of the African Methodist Episcopal Church on the northwest corner of Eighteenth and Pearl Streets. A founding member and the church's first pastor, Clay led the congregation for only two years before stepping down. (Courtesy Boulder Genealogical Society.)

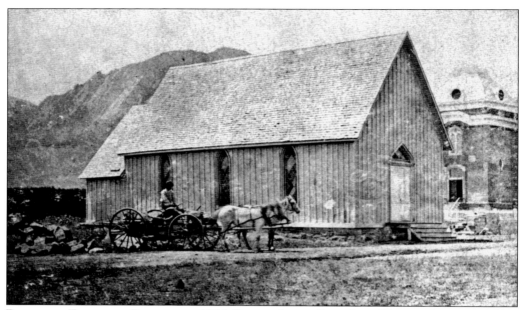

Reformed Episcopal Church, c. 1876. Despite the small number of Episcopalians in Boulder, there was still great interest in building a church. After holding services in several different public halls, the construction of the church was finished and dedicated in the summer of 1875. This simple church stood across from Central School (seen at the right) on the southeast corner of Front (Walnut) and Fifteenth Streets.

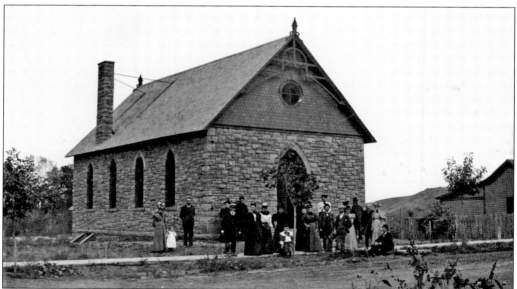

Seventh Day Baptist Church, 1897. Construction began on the only church on the south side of Boulder Creek in December 1893 at the southeast corner of Twelfth Street (Broadway) and Valley Road (Arapahoe Avenue). On May 31, 1894, Boulder's great flood washed out Jacob Faus's house, barely one block away, and the redirection of water undermined the church's foundation, washing away about 12 feet of it. The congregation rebuilt the church and dedicated it the following February.

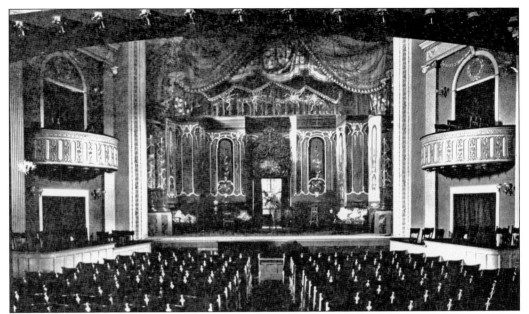

CURRAN OPERA HOUSE, C. 1906. James A. Curran opened his theater on October 2, 1906, at 2032 Fourteenth Street with a debut performance of the Augustus Thomas comedy *On the Quiet*. It held all types of musical concerts and dramatic and vaudeville performances. The theater quickly became popular for showing motion pictures, and in 1913, it began including sound with the films. In 1936, the Boulder Theater replaced the Curran, and it is still in operation.

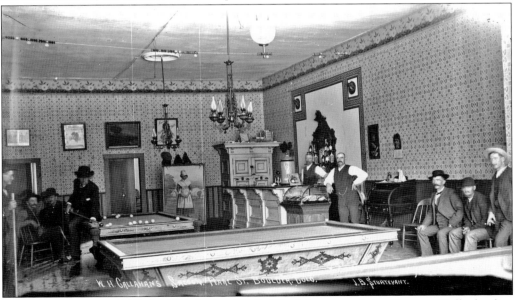

GAME OF POOL, C. 1895. In 1871, barber W. B. Westlake opened the Concert Hall, the first billiards parlor in Boulder. While his venture failed within months, billiards became more popular in the late 1870s, and many saloons included tables. Identified as W. H. Callahan's Saloon, this pool hall was possibly on the second floor of 1418–1420 Pearl Street, above Robert Coulehan's Silver Dollar Restaurant.

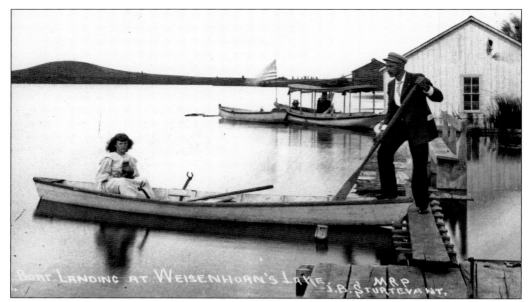

WEISENHORN LAKE, C. 1895. Boulder Brewery owner Frank Weisenhorn developed a small lakeside resort on his ranch just south of Valmont. It became a popular summertime destination for people to enjoy picnics, fishing, and boating. In the early 1920s, the Public Service Company purchased the land to construct the Valmont Power Plant, and Weisenhorn Lake became one of the three Valmont Lakes.

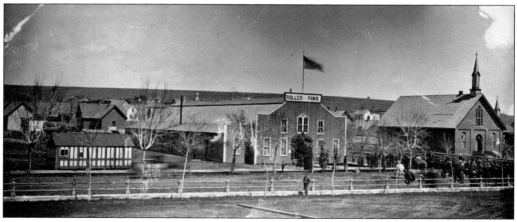

ROLLER RINK, 1886. Across from the Methodist church, at the corner of Fourteenth and Spruce Streets, Boulder's first roller rink opened in 1884 with great enthusiasm from the public. Jokingly noting that three doctors lived within two blocks for any new skaters in need, the *County Herald* newspaper followed many activities held at the rink. In one month, skating became so popular that owners William F. Abbott and James Aylor quickly extended the rink to 100 feet in length.

Six

E IS FOR EDUCATION

Beginning with the building of Colorado's first school in 1860, Boulder has consistently remained dedicated to education. Beginning in a one-room schoolhouse with multiple age groups, Boulder's youngsters gradually learned with other children of a similar age. Maintaining class size and consistent classroom locations grew difficult, and with the growing population of children, construction of new schools occurred nearly every decade.

As early as 1861, Colorado's new territorial legislature approved Boulder as the site for the first state university. However, it took another 16 years before the University of Colorado officially opened for classes. In 1870, a University Board organized with the intent of raising money to build the university. Fifty-two acres of land south of town had already been donated by Marinus Smith, George Andrews, and Anthony Arnett. In 1874, the legislature offered $15,000 on the condition Boulder could raise an equal amount. Marinus Smith, David Nichols, and Andrew Macky led the fund-raising efforts and raised more than $16,000. The legislature approved the amount, and in September 1875, the cornerstone was laid for the first university building, Old Main.

In 1898, a different type of educational experience began in Boulder. Created by a Texas-Colorado collaboration, the Chautauqua brought entertainment, culture, and education to the entire community. Developed on the former Batchelder ranch, the Chautauqua park consisted of a grand auditorium and dining hall. During the first summer, visitors lived in tents, absorbed lectures, saw performances, and explored the mountains. The park gradually built summertime cottages and additional lecture halls to expand the programs. Social reform lectures were popular, and the dramatic and musical performances increased. Outdoor activity expanded with increasingly popular mountain hikes and the "Switzerland Trail" railroad's wildflower picking and snowfield excursions.

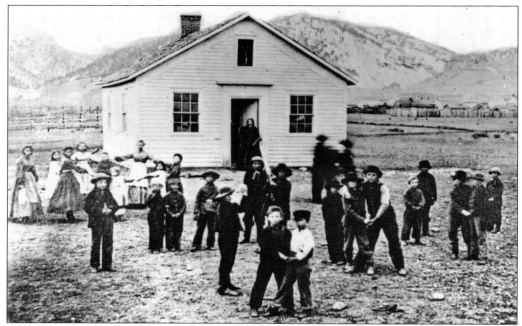

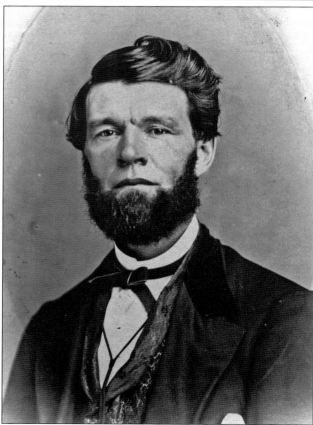

COLORADO'S FIRST SCHOOLHOUSE, C. 1865. Abner Roe Brown (left) arrived in Boulder in June 1860 to try his luck at gold mining. Only two weeks later, realizing a miner's life was not for him, he resumed his previous teaching profession. After three months of teaching 40 students in a small log cabin, Brown pulled the community together to build the state's first schoolhouse (above), located at Fifteenth and Front (Walnut) Streets. He enlisted men to cut down trees, haul logs to the town's sawmill for lumber, and build the 24-by-36-foot schoolhouse. He also raised money to purchase nails, shingles, windows, doors, and bricks, and then single-handedly constructed the stove and stovepipe. Completed by mid-October 1860, the school cost approximately $1,200. The following year, Brown moved to Denver and continued his work as a teacher, principal, and school superintendent.

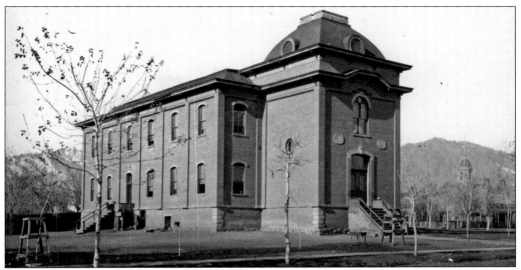

IN NEED OF MORE CLASSROOMS, 1873. In order to accommodate Boulder's growing population of children, the two-story brick Central School replaced the original schoolhouse. The classrooms filled quickly in a few years, necessitating the building of an annex. The school stood grandly for 99 years until its destruction to make room for a new parking lot. The loss of this building inspired the formation of the preservation organization Historic Boulder, Inc.

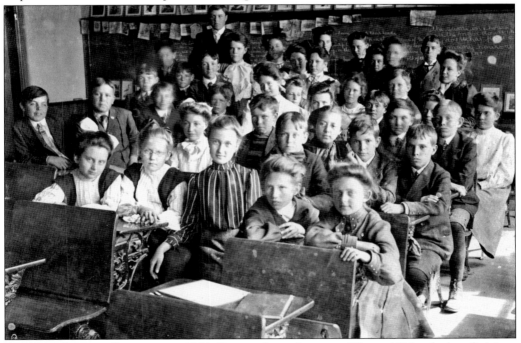

CENTRAL SCHOOL CLASSROOM, 1903. During the early years of Central School, class divisions depended on the age of the students. The youngest attended primary classes, then students progressed to second intermediate, to first intermediate, and, finally, to high school. Quite often, students outnumbered the classroom seats. Even with more schools available, by the turn of the 20th century, classrooms like this seventh- or eighth-grade class remained quite large.

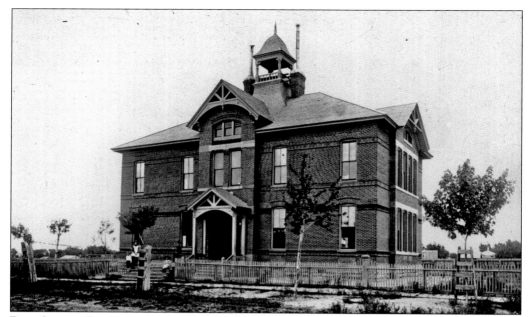

PINE STREET SCHOOL, C. 1882. Designed by prominent Denver architect Frank Edbrooke and built at Pine and Twentieth Streets, this school eased the crowding at Central School but only for a few years. In 1903, the school's name changed to Whittier in honor of poet John Whittier, with whom the sixth-grade class had corresponded. Today Whittier is the oldest school in Colorado still in operation.

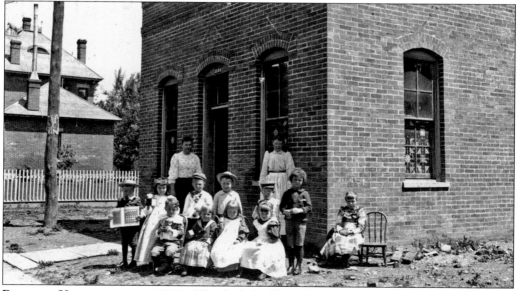

BOULDER KINDERGARTEN, 1890S. This little building, located at 2124 Thirteenth Street, first appears on a Sanborn insurance map of Boulder in 1895, as well as a listing in the 1896 city directory. A private school run by principal Mabel Golding-Dwyre, it aspired to conduct "the most approved scientific motherly principles of training and rearing the little folk." The kindergarten did not last long; by 1900, two residential buildings replaced the small brick structure.

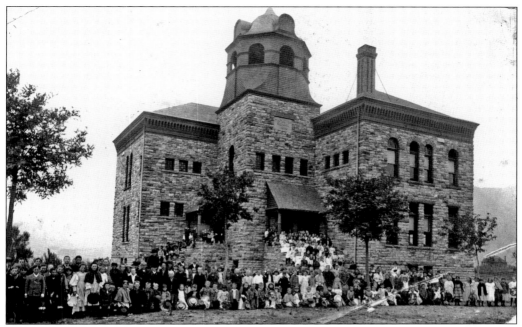

MAPLETON SCHOOL, C. 1892. Boulder's two schools became so crowded that by the end of the 1880s, the school board had to rent town buildings and churches for additional classrooms. The Mapleton School temporarily alleviated the crowding when it opened its doors in the fall of 1889. The newspapers reported the steam-heated structure housed eight "pleasant and cozy" classrooms with 342 new desks for the students.

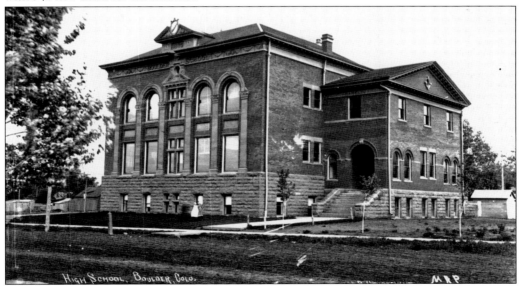

STATE PREPARATORY SCHOOL, 1895. For years, high school students attended classes at the various school buildings in Boulder. When the University of Colorado opened in 1877, it took over the responsibility for "prepping" high school students for university study. When that responsibility became too demanding for the university, the Boulder School Board built a dedicated high school at the southeast corner of Seventeenth and Pearl Streets.

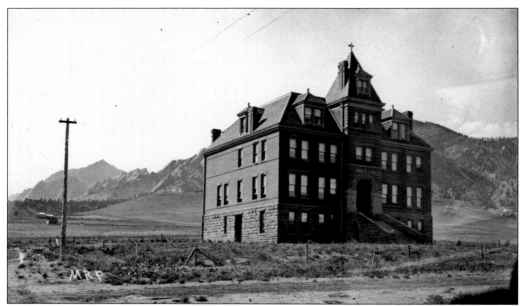

MOUNT ST. GERTRUDE ACADEMY, 1892. Established by three Sister of Charity nuns from Iowa, the academy, located at 970 Aurora Avenue, became the first significant private school in Boulder. The Catholic school focused on preparing young women for a college career. In 1919, two wings, a chapel, and an auditorium were added. The university bought the property in 1969, but a fire in 1980 closed the doors. Today it is an independent and assisted-living retirement community.

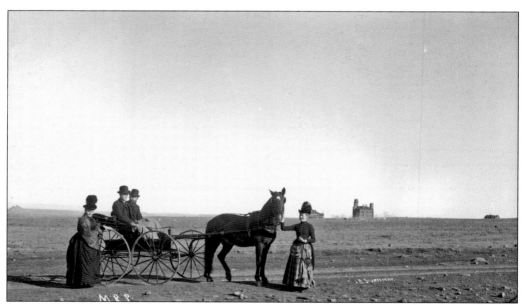

LOOKING EAST FROM NINTH STREET, 1886. The Buell family stops to pose near the Columbia Cemetery in 1886. The most prominent building on the desolate horizon is Old Main on the university grounds. Just behind the woman holding the horse's reins is the school's President's House.

University of Colorado, 1877. Completed in 1876, the first university building (Old Main) housed the entire university. It included the university president's quarters, classrooms, an assembly room, professors' offices, 11 rooms for use as student dormitories, a kitchen, and a dining room. The university opened with great fanfare, and classes began in September 1877. By the end of the year, it had received a $2,000 donation from Charles Buckingham for the development of a library.

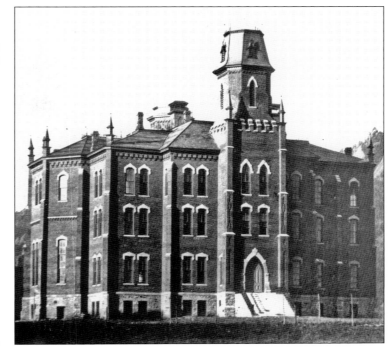

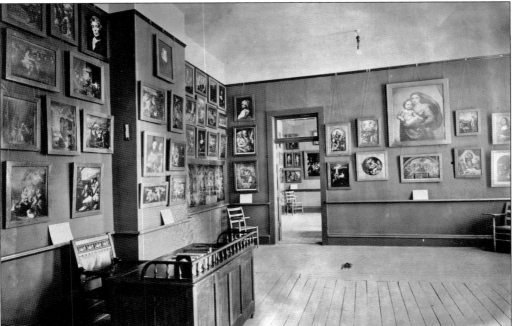

Old Main Classroom, 1900. In 1892, railroad and mining magnate Col. Ivers Phillips donated $1,000 to the University of Colorado's Latin Department. His generosity allowed the department to purchase paintings, sculptures, photographs, and archaeological drawings to illustrate Latin literature and inspire students with the wonders of the ancient Roman world. The artwork of the Phillips collection graced many of Old Main's classrooms.

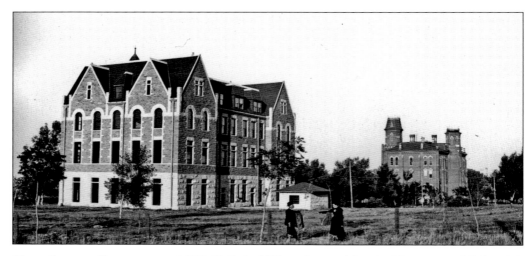

HALE SCIENCE BUILDING, C. 1900. Built in 1891 and named for the University of Colorado's second president, Horace M. Hale, the science building (above, foreground) was the second academic hall constructed on campus. The Hale Science Building housed the key scientific departments with classrooms for math (below), physics, biology, and civil engineering, as well as the law department. When Denver architects Varian and Sterner designed the building, they eliminated the use of iron nails and fixtures in the construction of certain areas of the hall, so the metal would not interfere with any scientific or radio experiments. (Courtesy Carnegie Branch Library for Local History.)

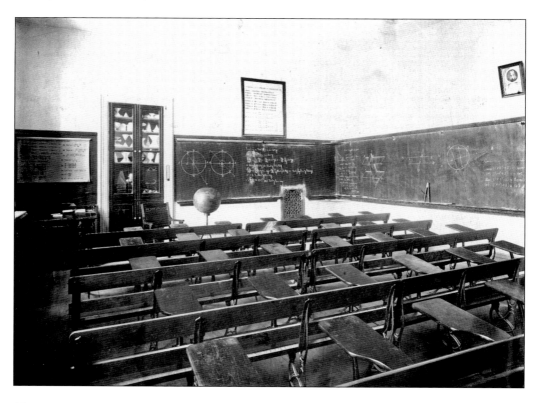

UNIVERSITY OF COLORADO GRADUATES, 1886. The earliest University of Colorado's graduating classes were quite small, with this graduating class consisting of only five men and one woman. Posing in front of Old Main are, from left to right, Clarence Pease, Victor Noxon (grandfather of Boulder astronaut Scott Carpenter), Frederick Chase, Edward Wolcott, and Judson Rowland. The sixth graduate (not shown) was Helen "Ella" Tyler.

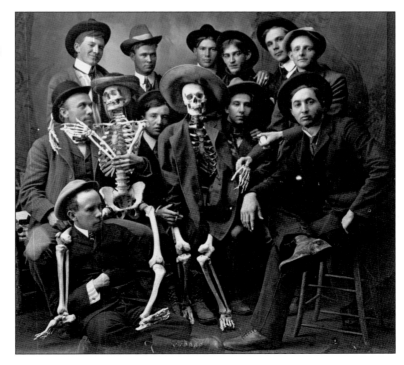

MEDICAL FRATERNITY, BEFORE 1910. Established in 1884, the University of Colorado's first Medical School Building stood where the University Memorial Center's fountain is today. One of the many fraternities, sororities, social clubs, and societies on campus, this medical fraternity illustrated the sense of humor of Boulder's future doctors. Note the young man on the right using his watch to time the skeleton's pulse.

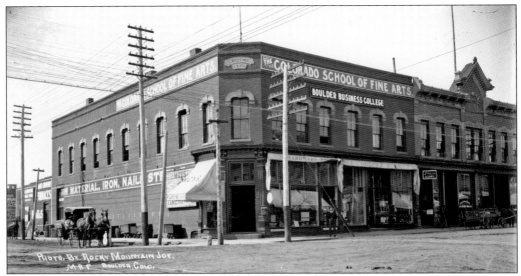

BOULDER BUSINESS COLLEGE, 1901. Established by Charles L. Lewis around 1900, this school specialized in preparing young men and women for the work environment by teaching business skills such as typing, dictation, handwriting, and shorthand. The school was located on the second floor of the Boettcher Building, on the southwest corner of Twelfth (Broadway) and Pearl Streets (above). Five students made up the college's first graduates in 1901 (below). Pictured from left to right are (first row) Emma Anderson, Maude Hayward, and Grace Fairchild; (second row) Lyman McIntyre, Clara B. Munger, and owner and principal Charles L. Lewis.

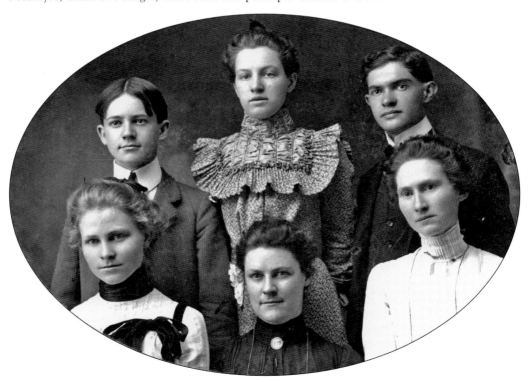

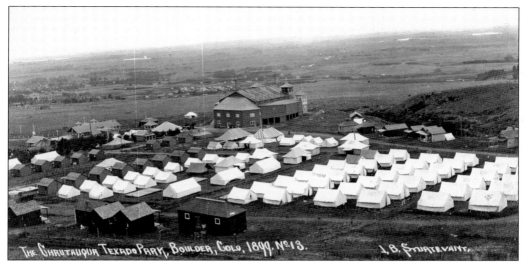

CHAUTAUQUA PARK, 1899. As the East Coast Chautauqua movement expanded during the end of the 19th century, a group of Texans began looking to Boulder for an educational mountain retreat to escape the southern summer heat. Boulder's Chautauqua at "Texado Park" opened on July 4, 1898. It quickly grew into a popular summer destination for individuals and families to spend the months absorbing various lectures, musical performances, discussions, and participating in mountain outings.

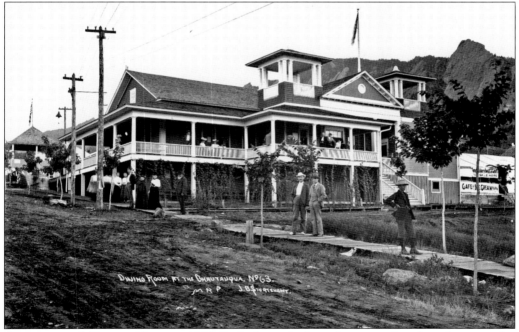

CHAUTAUQUA'S DINING HALL, C. 1900. Built alongside the auditorium in less than three months, the dining hall offered guests daily scheduled luncheons and dinners. The dining experience in the pleasantly decorated large hall included beautiful views and band music, but the quality of food and wait service from college students left much to be desired. Unfortunately, the following season the food did not improve.

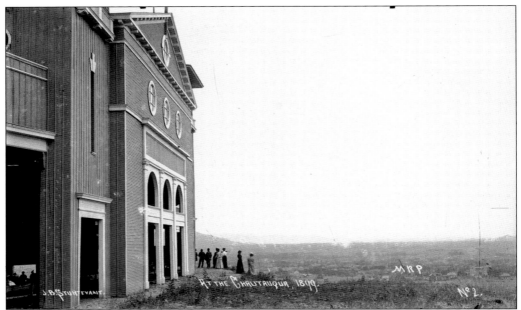

CHAUTAUQUA AUDITORIUM, 1899. Located on the hills below the Flatirons, visitors take a break from events to look down upon Boulder's mostly treeless valley (above). Favorably compared to the Salt Lake City Tabernacle, the auditorium's acoustics made lectures and musical events popular. Some well-known guests included the social reformer and peace activist Jane Addams, evangelist Billy Sunday, and bandleader John Phillip Sousa. By the end of Chautauqua's first season, reviews about the performances at the auditorium were generally good (below). However, the large building with its open doorways and windows proved to be quite drafty, causing the powdery dirt floor to become air-borne and occasionally limit visibility. In 1898, Boulder viewed its first silent film, scenes from the Spanish-American War by Thomas Edison. Throughout the coming decades, films gained in popularity and became more economical than traveling entertainers.

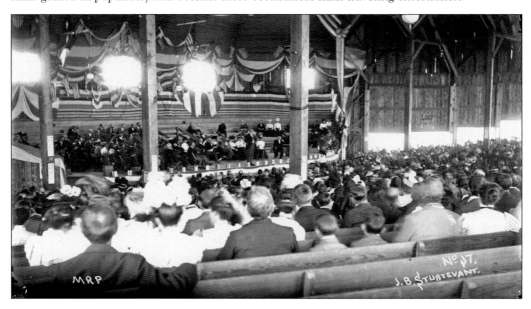

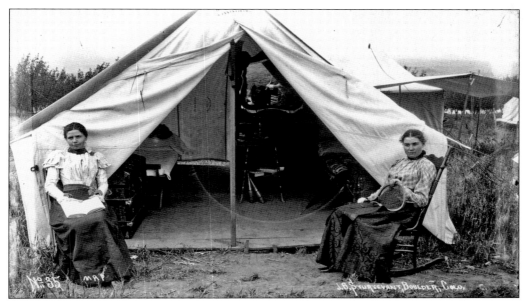

TENT LIVING, C. 1898. Tents were the primary source of housing during Chautauqua's first season. Different sizes of tents were available depending on a guest's budget, and furniture was available for rental for a reasonable fee. Campers often decorated their tents with rugs, flowers, and pine boughs, but "roughing it" became more of a hardship as the season progressed. The construction of cottages became a priority in the following years.

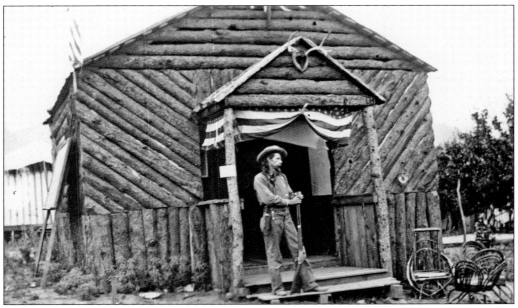

WOODBINE STUDIO, 1900. As Chautauqua's official photographer, "Rocky Mountain Joe" Sturtevant built a small studio on the park grounds. Aside from taking visitors' portraits and documenting Chautauqua's events, Joe led tours and gave campfire talks, thrilling young and old alike with his tall tales of the Civil War and life as an Indian scout.

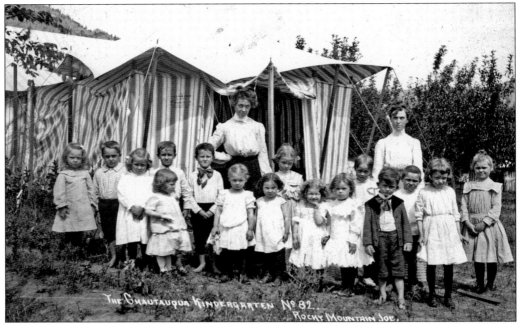

CHAUTAUQUA KINDERGARTEN, C. 1898. A child's life at Chautauqua offered everything a little mind could want. Classroom schooling provided contrasting structure to the lure of outdoor freedom of roaming the park and mountain trails. Hikes, burro rides, sports, and storytelling kept the children occupied during the early years. In 1913, the city constructed a playground and, in 1915, a wading pool.

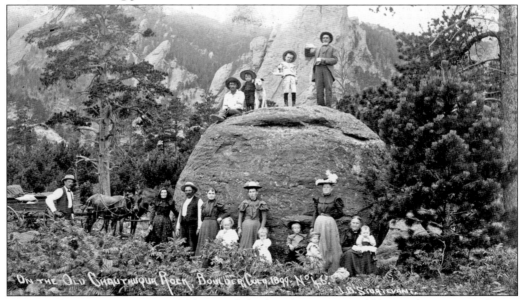

TOMATO ROCK, AROUND 1899. Hiking and climbing became incredibly popular activities during the summer months. The Weaver and Nobel families stop to pose at "Old Chautauqua Rock" with the Flatirons in the background. Other popular hikes included day trips along the Mesa Trail and the Quarry Road. Steeper treks up Flagstaff and to the Royal Arch were also favorites.

94

Seven

IN THE MOUNTAINS AND AROUND TOWN

Reliable transportation was key to the success of Boulder and the mining towns. Road building into the mountains in the early decades was a difficult task, often making for narrow and bumpy routes. Roads in town were not necessarily better. Residents often endured incessant dust during dry spells or deep sticky mud during the spring thaw.

The first train reached Boulder in 1873, but it would take another decade before the construction of the Greeley, Salt Lake, and Pacific Railroad reached some of the mountain communities. The trains transported people and supplies up and down the canyons, allowing for easier access to goods and services. With the arrival of the railroad, Boulder merchants could transport more goods for greater profits to the mining camps. The mines benefited as well because they were now able to ship ores to the mills faster and more economically than by freight wagons.

As Boulder grew, the town's infrastructure needed to update and expand. As the number of county officials grew, a courthouse with a modern jail was built to accommodate the increase. The fire departments gradually modernized as fire transportation and technology evolved. Transportation and communication improved dramatically as Boulder moved from horses and wagons to automobiles, and from the telegraph to the telephone.

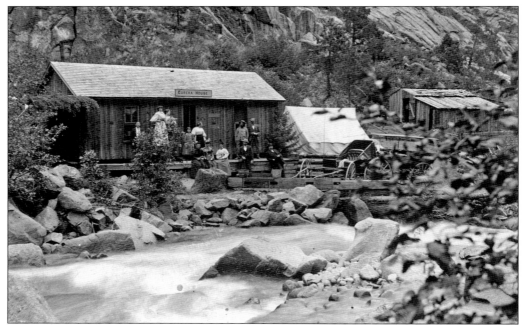

EUREKA HOUSE, C. 1890. Despite up-front investments made by Boulder businessmen, charging tolls was necessary for building roads leading up the mountain canyons. Located on the same site as a former toll station near Boulder Falls, the Eureka House provided service as a stage stop and took tolls. It was also a location to change horses and a place where travelers could enjoy a meal along Boulder Creek.

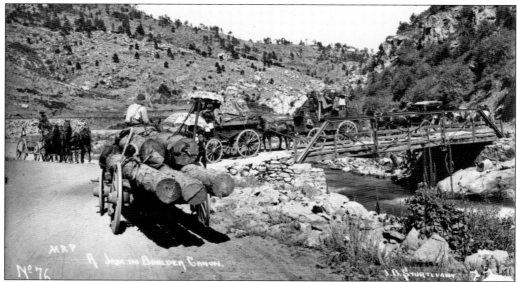

TRAFFIC JAM IN BOULDER CANYON, C. 1890. Despite the improvements made in road building techniques throughout the decades, travelers still endured narrow roads and bridges in the mountains. This photograph captures the difficulty of orchestrating the right-of-way for multiple wagons carrying furniture, ore, and logs with passenger buggies across a bridge at the intersection of Boulder Creek and Four Mile Canyon.

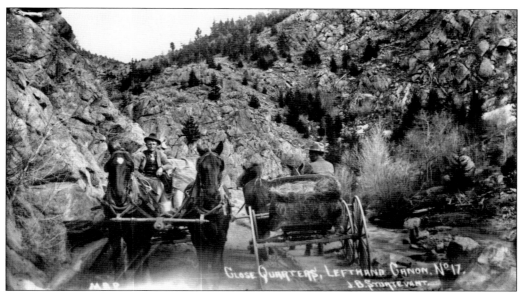

NARROW CANYONS, C. 1890. Many canyon roads followed the creeks, and when faced with exceptionally difficult terrain, the construction of a bridge over the water typically solved the dilemma. Blasting through rock and grading tough soil often forced roads to be quite narrow with few turn outs to allow for passing. Heavy rains and flooding frequently caused serious road damage, usually forcing the relocation of road beds or abandoning them entirely.

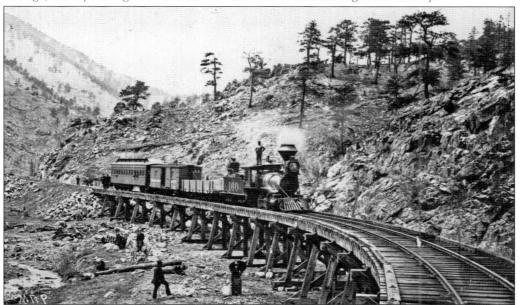

GREELEY, SALT LAKE, AND PACIFIC TRAIN NEAR SUNSET. This rail line became the county's first narrow-gauge railroad in 1883. Trains ran up Boulder Canyon, north along Four Mile Canyon to Salina, then west to Pennsylvania Gulch (later renamed Sunset). The railroad continued operating, despite financial struggles, until 1894, when a powerful spring flood destroyed nearly everything down the canyons. The mountains remained quiet until 1898, when the Colorado and Northwestern company rebuilt the line.

Colorado and N.W. Railroad. Shay Engine

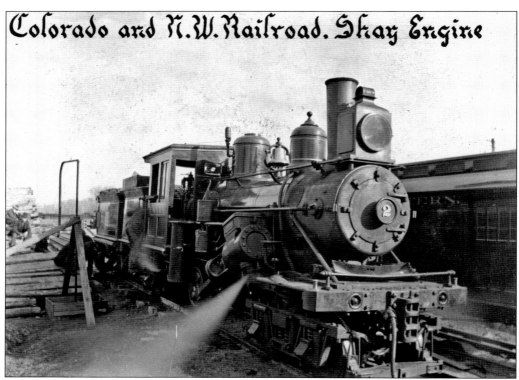

COLORADO AND NORTHWESTERN TRAINS, c. 1900. The Colorado and Northwestern railroad company special ordered Engine No. 2 (above) from the Pennsylvania-owned Climax Manufacturing Company. Specifically designed to pull heavy loads, this 50-ton locomotive hauled supply trains to the mountains and ore trains to the mills east of Boulder. Onlookers described the engines sounding "as if they were doing 60 miles an hour when they were only doing about six." In April 1901, Engine Nos. 31 (left) and 32 were clearing snow from the tracks near Camp Frances when an avalanche swept the two trains down a gulch. Four men died in the wreck. An earlier photograph of Engine No. 31 shows (from left to right) conductor Robert J. "Jap" Reed, engineer Pat Dinely, miner J. L. Lloyd, and an unidentified brakeman.

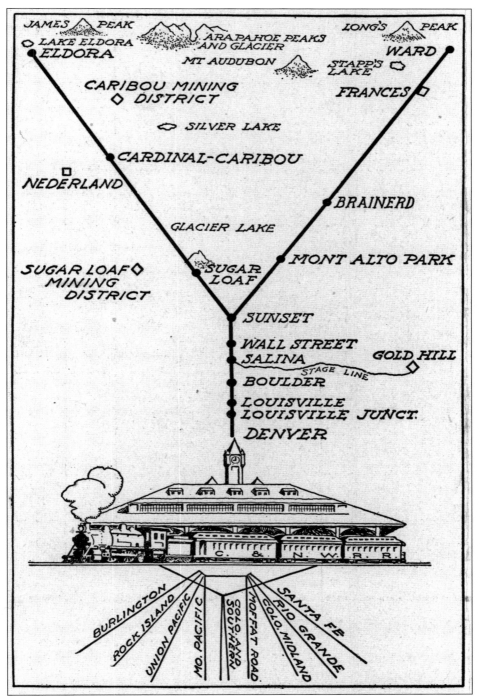

SWITZERLAND TRAIL, C. 1906. The map from a *Trip to Cloudland* wildflower excursion brochure illustrates all the mountain sites accessible on the Colorado and Northwestern Railroad, also known as the Switzerland Trail. The railroad ran its own trains out of Union Station in Denver, simplifying the riders experience by eliminating unnecessary transfers along the route to the mountains.

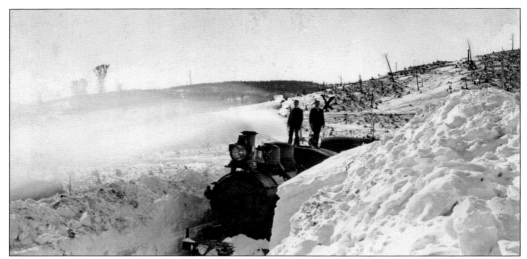

SNOW DRIFTS, C. 1900. None of the Colorado and Northwestern trains had rotary snowplows to clear the tracks, so they resorted to a technique called "bucking." With large snowplows attached to the trains' engines, the trains forced snow up and over the drifts, then backed up to build force for the next clearing attempts. The "X" marks Fred Conrad, the conductor for Engine No. 30.

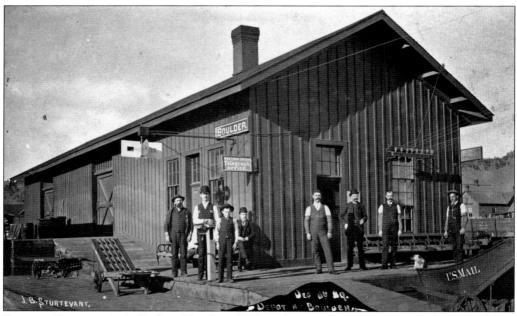

FREIGHT DEPOT, 1889. Built at Tenth and Water (Canyon) Streets in 1883, this train depot replaced the old one in the east part of town near Twenty-second and Pearl Streets. It managed both freight and passenger trains until construction of a passenger depot at Fourteenth and Water (Canyon) Streets in 1890. The Tenth Street depot operated until August 10, 1907, when an explosion completely destroyed the building.

PASSENGER DEPOT, 1900. Built by the Union Pacific Railroad in 1890, the dedicated passenger depot stood at Fourteenth and Water (Canyon) Streets. It also served as a hub for Boulder's electric streetcar line and the Denver and Interurban Railway. From left to right are Union Pacific depot employees Robert Strain, Sidney Majors, Ora Brown, Thomas Giller, S. P. Miller, Alfred Giller, J. M. Wilcox, George Sherman, and Al French.

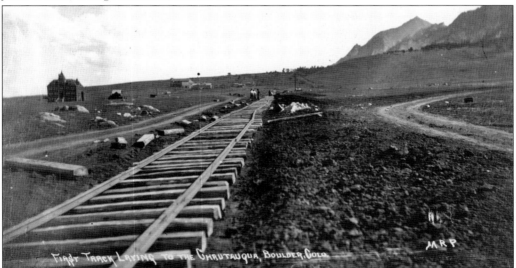

FIRST TRACKS TO CHAUTAUQUA, 1899. After long financial delays, March 3, 1899, witnessed the ground-breaking for a short streetcar line to Chautauqua. Three and a half months later, 11 brown and yellow electric railway cars brought visitors from the downtown depot to Chautauqua's Strawberry Day festivities for a 5¢ fare. This photograph shows a view up Ninth Street, with Mount St. Gertrude Academy on the left and Chautauqua in the distance.

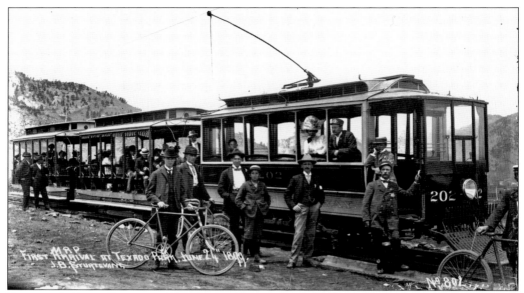

BOULDER'S FIRST ELECTRIC STREETCAR, 1899. The first run of Boulder's 3-mile-long electric streetcar line occurred at 7:00 a.m. on June 24, 1899. After a smooth test run, at least 6,000 people paid their 5¢ fare to ride from downtown to Chautauqua that first day. Traveling at 15 miles per hour, some riders enjoyed the experience so much they took the round-trip without even leaving the streetcar.

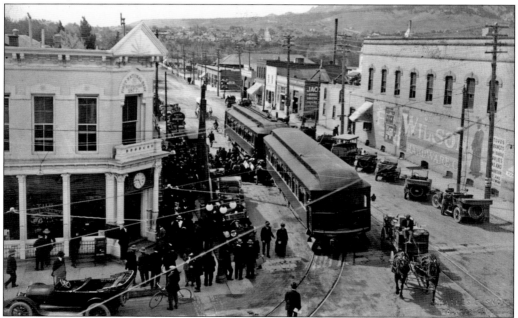

DENVER AND INTERURBAN RAILROAD, 1916. The inaugural run of the Denver and Interurban occurred on June 23, 1908. The large green train cars traveled a circuit route from Denver to Marshall, with a small detour to Eldorado Springs, then to Boulder, and back to Denver via Louisville. The trip, leaving from the Twelfth (Broadway) and Pearl Streets stop in Boulder, took just over an hour to get to Denver.

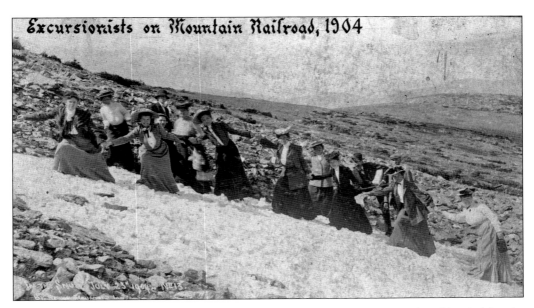

Excursionists on Mountain Railroad, 1904

SWITZERLAND TRAIL OF AMERICA EXCURSIONS, 1904 TO 1908. The railroad hauled freight as well as large groups of passengers. Organized summer excursions became popular with many church groups and fraternal organizations. However, the special trips, such as the moonlight ride to Mount Alto Park, excursions to the slowly melting snowfields (above), or the annual wildflower trips (below) became long-awaited yearly favorites. People enjoyed picnics, stopped to pick bunches of wildflowers, or pelted each other with snowballs on the June "Snowball Special."

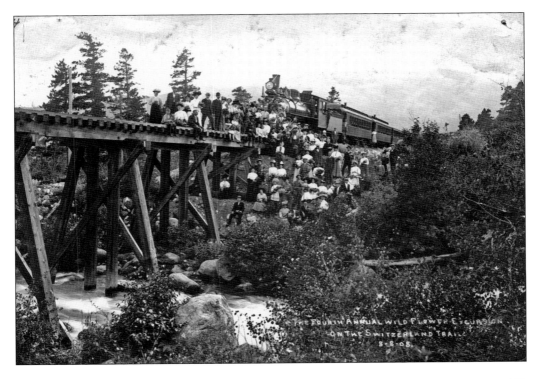

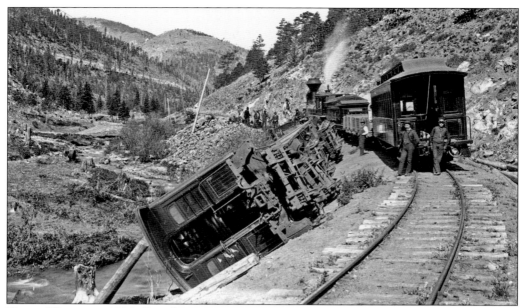

TRAIN WRECK, C. 1890. Derailments were constant concerns for the train engineers and crews. Sometimes when the curves were too tight, the brakes failed or the weather caused problems. Accidents occurred quickly, and the men often died. Barely a half of a mile below Sunset Station, the Union Pacific, Denver, and Gulf Engine No. 154 carries a regularly scheduled train past the wreckage of the Denver, Leadville, and Gunnison No. 60.

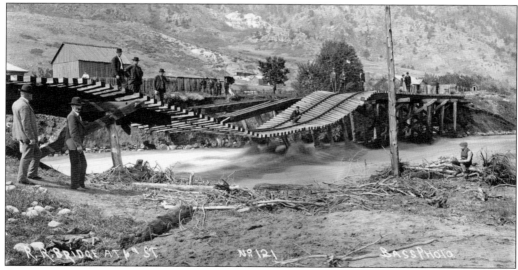

GREAT BOULDER FLOOD, 1894. After heavy winter snows, with creeks high with spring runoff and several days of rain, a wall of water rushed down Boulder's canyons during the early morning of May 31, 1894. Mining towns along Four Mile Canyon and Left Hand Creek suffered greatly. Ten feet of water submerged some parts of Boulder, and little remained of the railroads. Onlookers inspect the precarious Fourth Street bridge the following day.

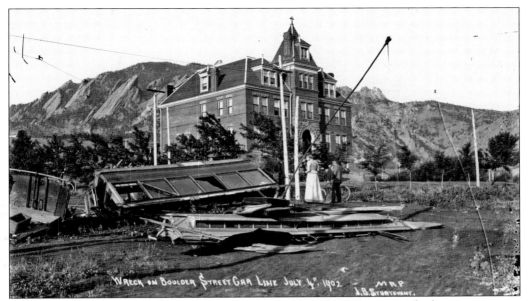

STREET CAR ACCIDENT, 1902. On the evening of July 4, 1902, two packed streetcars were descending down a steep grade from Chautauqua when the brakes failed. The cars swiveled on the tracks with the front train car tipping over and coming to a tragic stop just in front of Mount St. Gertrude's Academy. One woman died at the scene, and more than 20 people were injured. Most of the casualties occurred in the first car.

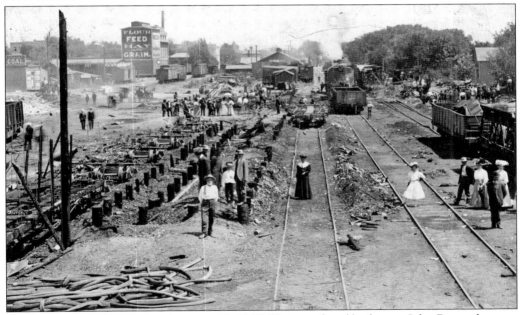

FREIGHT DEPOT EXPLOSION, AUGUST 10, 1907. Union railroad brakeman John Reeves became livid when he discovered the railroad hired strikebreakers during the railroad switchmen strike. With help from Frank Kiser, the two set fire to a caboose and then another car, which contained 2,350 pounds of dynamite. The explosion completely destroyed the depot, 30 railcars, left a 25-foot crater 10-feet deep, seriously injured 31 men, and killed four.

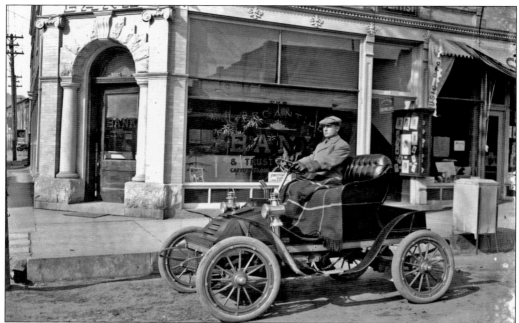

EARLY CARS IN BOULDER, 1907. Mercantile Bank founder Houston Jones proudly displays his new Autocar Runabout in front of his bank. Purchased in 1907, Boulder's automobile register shows the vehicle having a two-cycle, 12-horsepower engine and was painted blue. Advertisements of the era boast the $900 automobile as "practically vibrationless," a great hill climber, and able to reach top speeds of 35 miles per hour.

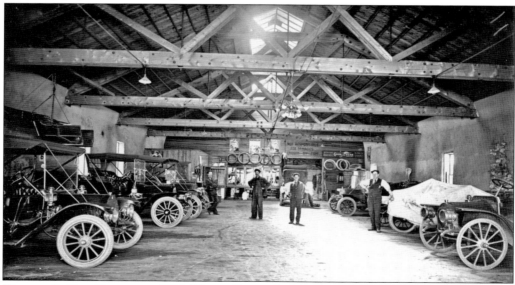

WARREN L. COX GARAGE, C. 1910. Warren Cox worked for the Phoenix Iron Works as a machinist starting about 1905. Three years later, Phoenix opened a general automobile storage and repair shop, putting Cox in charge of the department. Around 1910, he opened his own car garage, located at 1002 Pearl Street. Some of the signs on the back wall of his garage are advertising Michelin and Goodyear tires.

COUNTY COURTHOUSES, 1867 AND 1882. The county erected a brick building at 1018 Pearl Street (above) to serve as the new courthouse in 1867. Occupied by assayers Coving and Teal at the time of the photograph, the building originally included 12-inch-thick brick walls with the sheriff's office and jail cells in the basement (note the small windows at lower left). Designed by Denver architect Frank Edbrooke and completed in 1882, the new courthouse (below) stood on Pearl Street between Thirteenth and Fourteenth Streets. The modern building included gas lighting and steam heat with enough space for steel-clad jail cells, jury rooms, and offices for all the county officials. The courthouse stood until 1932, when a fire destroyed it. In 1934, a new art deco–style courthouse replaced the old one, where it still stands.

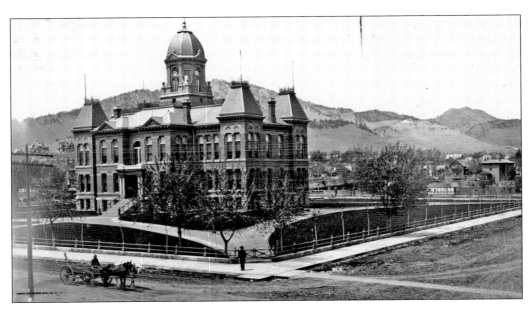

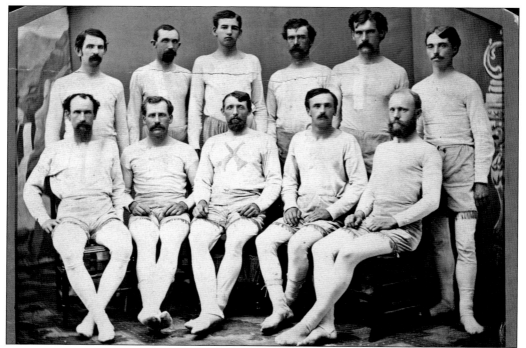

FIREFIGHTING, 1877. Founded in July 1875, Boulder Hose Company No. 1 became the second of the early fire companies in Boulder. Prior to these volunteer organizations, citizens present at a fire were obligated to take orders from appointed fire wardens. If an individual refused to cooperate, he was fined $5 and jailed for the length of the fire.

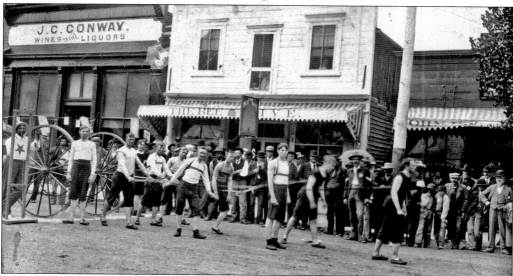

FIREMEN'S COMPETITION, C. 1890. Until 1898, the hose carts and hook-and-ladder wagons were man-hauled. Wanting to be the fastest, each volunteer team fiercely competed in races. The hook-and-ladder teams ran their wagons 400 feet, raised a ladder, and a man climbed to the top. Hose teams competed by sprinting 400 feet to a hydrant, attaching the hose to the hydrant, and running water through the nozzle.

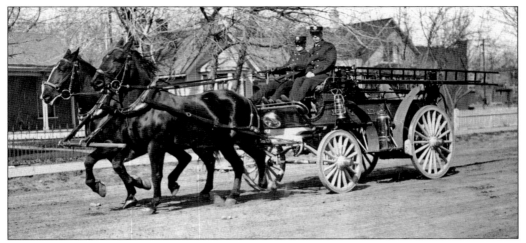

HORSE-DRAWN FIRE WAGON, C. 1910. After purchasing a new wagon and remodeling the firehouse, Boulder received its first horse team in 1898. As Boulder grew, it was in need of additional fire stations, and stations Nos. 2 and 3 went up in 1908. Ben Morgan (driving) and Dan Schaefer (riding) from Fire Station No. 3 race down the 900 block of Pearl Street, led by horses Doc and Pat.

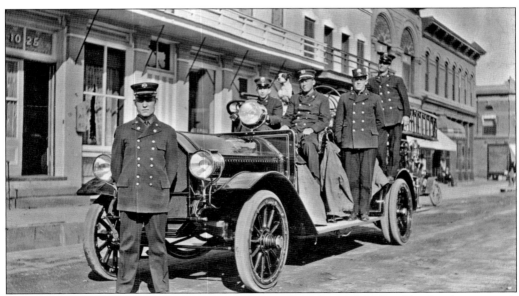

NEW FIRE TRUCK, 1913. Emil Johnson proudly stands in front of the Boulder fire department's new 1913 Seagrave fire truck. Purchased for $5,000, the six-cylinder, 90-horsepower truck could easily climb any of the hills in Boulder, even when fully equipped. Driving is Art Pettingill, Ford Dunning is sitting in front next to Pettingill, Frank Johnson is standing on the running board, and Bob Burgener is at the rear. Duke the dog sits behind Pettingill.

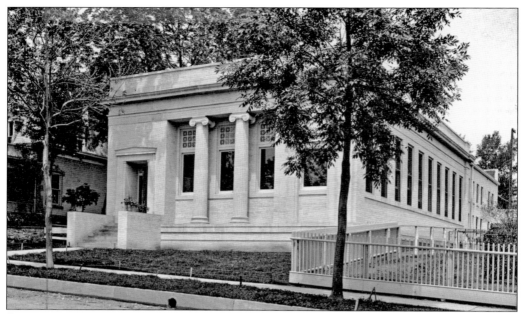

CARNEGIE LIBRARY, 1907. In 1869, the offices of the *Boulder County Pioneer* newspaper housed the town's first reading room. Throughout the decades, small, private, rental libraries opened, and various literary clubs organized, but not until 1907 would Boulder have a proper public library. Built with a donation of $15,000 from steel magnate Andrew Carnegie, the Carnegie Library was the original Boulder Public Library building. Today it houses Boulder's local history archive.

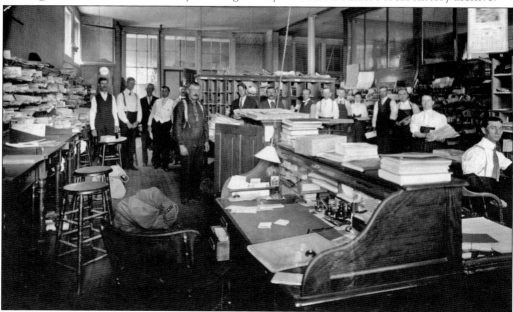

INSIDE THE POST OFFICE, C. 1905. Included in this post office staff photograph is Mary Cowie (in the far back, at right), who later became Boulder's first female postmaster in 1922. This post office operated in the Masonic Temple, located at 1927 Fourteenth Street, from 1900 until 1910, when it moved to its current location at the northwest corner of Fifteenth and Walnut Streets.

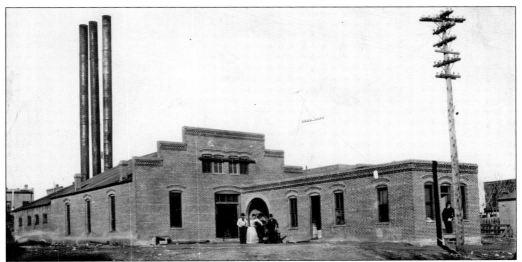

ELECTRIC COMPANY, C. 1890. Beginning slowly in 1886, early installations of electrical lights included lighting up the courthouse dome "just for the fun of it" (according to the *Boulder County Herald* newspaper). Electricity aided in nighttime bank bookkeeping, and the roller skating rink, located at Fourteenth and Spruce Streets, also received illumination. Built in 1889, the Boulder Power and Light Company, located at 1231 Walnut Street, generated much of Boulder's electricity until the building was razed and replaced by the YMCA building in 1906.

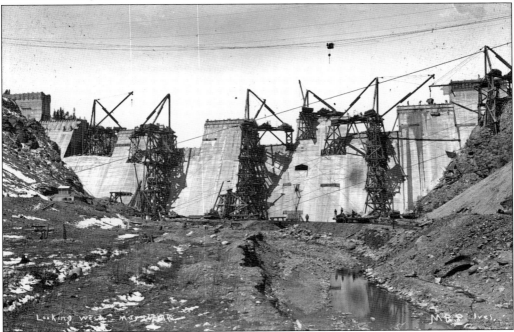

CONSTRUCTION OF BARKER DAM, 1910. Hannah Barker of Boulder sold her Nederland meadow lands to the Colorado Power Company for the construction of the Barker Dam. Built with finely engineered expansion joints, the dam could safely expand and contract with the seasonal temperature fluctuations. Upon completion, the Barker Dam became part of a system of hydroelectric dams and power plants around Colorado.

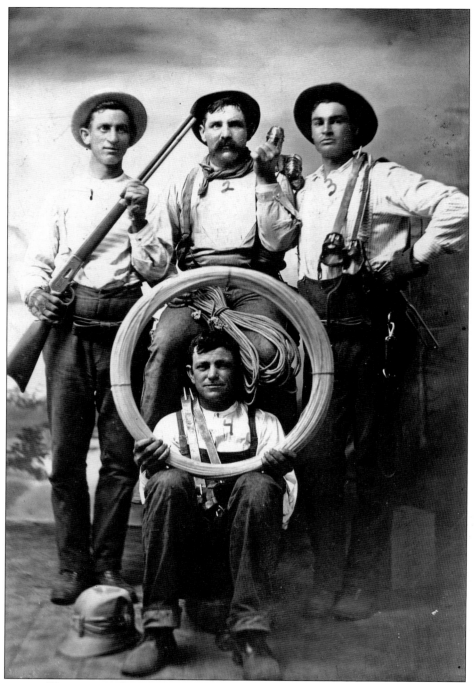

COLORADO TELEPHONE COMPANY LINEMEN, C. 1904. Boulder's first telephone system was installed in 1881 with only a small number of businesses and private homes having access. After 1893, telephone use quickly expanded, giving men jobs setting up poles, stringing wires, and connecting the lines. The three men standing are identified (from left to right) as Jacob Weiskopf, Butch Nagel, and Tom "Spud" Day. The lineman sitting is John Chrire.

Eight

STAYING HEALTHY AND KEEPING FIT

Frontier medicine was quite primitive by today's standards, and typical of other frontier towns, Boulder's residents likely only saw a doctor when they were ill or injured. Colorado's altitude and dry climate proved exceptionally beneficial to those suffering from tuberculosis. Many people with health problems traveled west when the Boulder-Colorado Sanitarium opened in 1896. Initially catering to tubercular patients, it later expanded its services, allowing for broader treatment options. In 1918, the sanitarium cared for many who succumbed to the influenza epidemic.

Aside from more traditional medicine, people often looked to alternate solutions for improving their health. Natural springs dotted the mountains around Boulder, and some were quickly built and marketed as health resorts. Springdale's Seltzer House and the Eldorado Springs Resort gained great popularity as Boulder's residents looked for an easy fix to all their ailments.

Outdoor activities and sports have been a part of Boulder's culture since 1869, when the first baseball teams organized and the earliest bicycles hit the streets. As Boulder became more prosperous, residents had more leisure time to participate in or watch sports. By 1889, the University of Colorado had its first football team, with baseball, basketball, and boxing teams organizing in the 1890s. The formation of the Chautauqua Climbers Club in 1898 brought structure to the already popular hiking and mountain climbing. Organized group hikes and longer overnight excursions tested the stamina of tourists and residents alike.

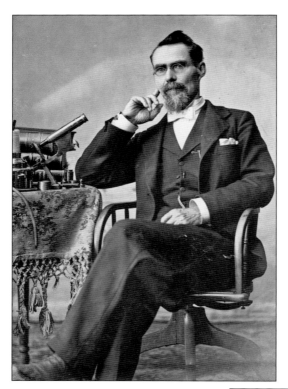

DR. HENLEY ALLEN, 1897. Moving to Valmont in 1865, Allen became one of the earliest doctors in the Boulder area. He served as a surgeon for the Union Pacific Railroad, held the position of coroner, served as a founding member of the Boulder County Medical Society, and ran a drugstore. Aside from practicing medicine, Allen established the county's first newspaper, the *Valmont Bulletin*, in 1866, and surveyed the grounds for the future University of Colorado.

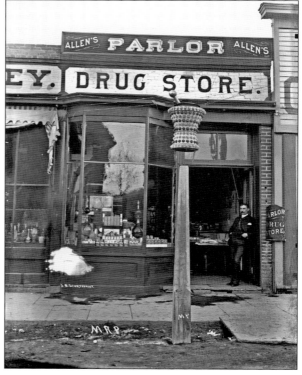

DRUGSTORE, C. 1886. Prior to the establishment of pharmacies, doctors managed their own supplies of medicine for their patients. In 1865, Dr. Henley Allen brought a large quantity of pharmaceuticals with him and began a drugstore in Valmont, likely the county's first. In 1875, Dr. Allen moved his store to Boulder, shown here at 1308 Pearl Street, with the apothecary symbol of the mortar and pestle out front.

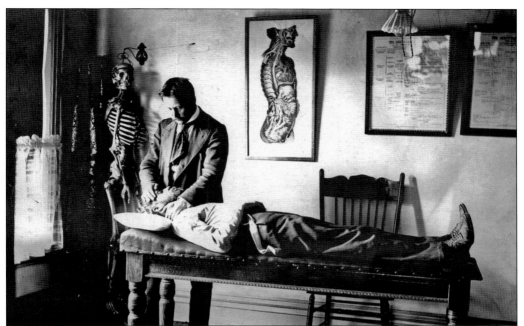

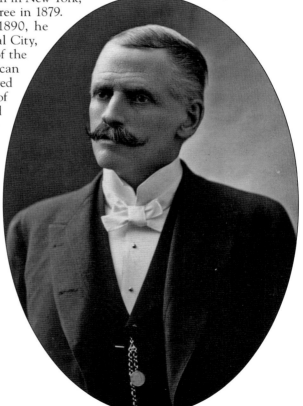

DR. LAFAYETTE COMAN, C. 1890. Born in New York, Coman (right) earned his medical degree in 1879. Before moving to Boulder around 1890, he practiced medicine in Denver, Central City, Caribou, and Nederland. A member of the Boulder County, Colorado, and American Medical Societies, Dr. Coman also lectured at the University of Colorado's School of Medicine, teaching minor surgery and bandaging. During the 1890s, he saw patients at his offices (above), located at 1231 and 1227 Pearl Street.

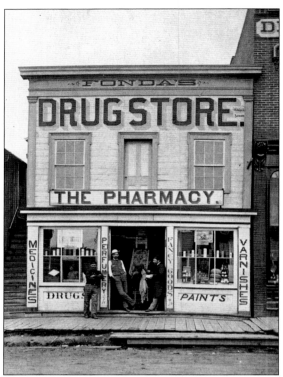

GEORGE F. FONDA, C. 1885. In 1874, at the age of 16, George arrived in Boulder to work in the drugstore operated by his brother Giles. Upon hearing of the silver strikes in Leadville, Giles headed for the mountains, leaving George to run "the Pharmacy" (left). George expanded the business and eventually bought out his brother. Fonda's drugstore stocked an array of pharmaceuticals alongside perfume, paint, newspapers, and magazines. Specialty items received prominent displays, such as a new shipment of Spalding baseball equipment (below). An avid baseball player, George also played the tuba in the Boulder Band and served as a firefighter and fire chief on the Macky Hose Team. Another family business began by Giles Fonda was a bottling company. George and his younger brother Clinton grew the soda bottling business, which operated for decades as the Boulder Bottling Works.

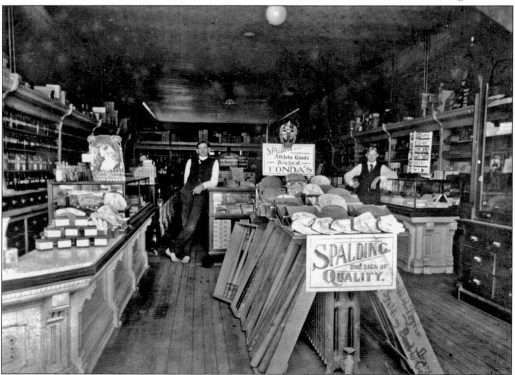

IN THE DENTIST'S CHAIR, C. 1890. Frontier dentistry most often resulted in tooth extraction, typically performed by home practitioners, physicians, and even blacksmiths. Alcohol remained a popular painkiller even as new forms of anesthesia, such as chloroform and ether, gained wider use, but Colorado's high altitude sometimes caused problematic side effects.

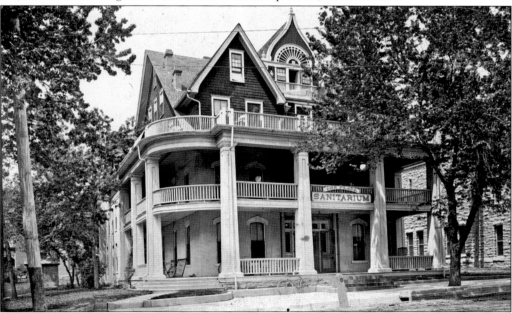

PLACE SANITARIUM, C. 1905. Built in 1876 at 2121 Twelfth Street (Broadway), this structure housed four hotels, a hospital, and a mortuary during its 89 years. The Place Sanitarium operated here from 1903 to 1909. An advertisement states that the hospital catered to people of moderate means and specialized in women's digestive and nervous diseases, as well as care for expectant mothers. A parking lot now occupies the site of the building, which was demolished in 1965.

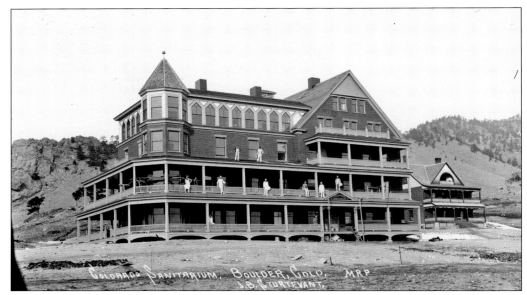

BOULDER-COLORADO SANITARIUM, 1896. Operated by the Seventh-day Adventists as a branch of Dr. John H. Kellogg's famous Battle Creek, Michigan, sanitarium, Boulder's 60-bed facility initially treated tuberculosis patients. Doctors later focused on other illnesses, providing a variety of treatments, including hydrotherapy, radium therapy, and emphasizing a strict natural food diet. Dr. Katherine Lindsay worked with Dr. Kellogg in Michigan and took a lead role in the Boulder hospital, as well developing the nurses' training program. Dr. Lindsay is sitting in the middle row, third from the left in this staff photograph, taken about 1898 (below). The five-story building, located at Fourth and Hill (Mapleton) Streets (above), had several additions throughout the years. The original building was razed in 1957, and the remaining additions became Memorial Hospital in 1962. Today the building is owned by the Boulder Community Hospital and operates as the Mapleton Center.

ALPHA TAU OMEGA FRATERNITY, 1918. The influenza epidemic first struck Boulder at the University of Colorado campus in September 1918. Soldiers who recently arrived from Montana for training brought the disease with them. As the flu spread, the Alpha Tau Omega house, located at 1229 University Avenue, turned into a hospital, taking in the afflicted soldiers. At least six soldiers died here.

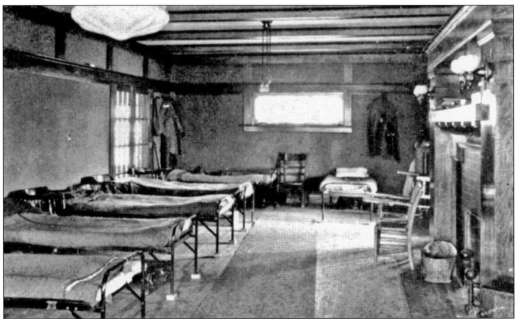

MAKESHIFT HOSPITAL BEDS, 1918. Within one week, 95 soldiers became infected with influenza, and several other fraternities opened their doors. The Sigma Chi house also became a hospital, and the Sigma Phi Epsilon fraternity became a convalescent ward. As the epidemic worsened, the entire university closed down. (Courtesy Carnegie Branch Library for Local History.)

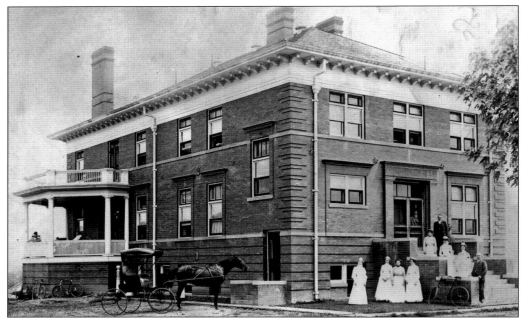

UNIVERSITY HOSPITAL, C. 1903. Built in 1898, this hospital served the public, University of Colorado students, and staff. As the only hospital other than the Boulder-Colorado Sanitarium, the Boulder's Woman's Club desired expanded services and pushed the university to add a nursing program, a maternity ward beyond the 40-patient capacity, and a day-care nursery.

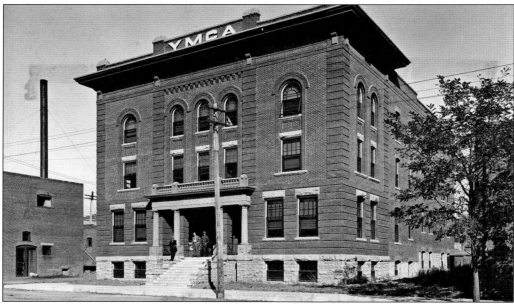

YMCA, C. 1908. Organized in Boulder in 1874, the first building constructed by the Young Men's Christian Association (YMCA) in 1876 had an open reading room and was advertised as a safe place free from vice for homeless men and visitors. In 1908, the new building, located on Walnut Street between Twelfth (Broadway) and Thirteenth Streets, housed a reading room, game rooms, bowling alleys, a gymnasium, a kitchen, banquet rooms, and 35 furnished rooms.

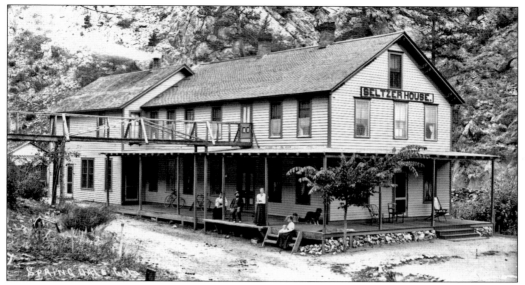

SELTZER HOUSE, BEFORE 1894. Touted for its healing properties, the naturally carbonated mineral springs found along James Creek made Springdale famous as an early health resort. The marketing of the seltzer water began in the 1880s, claiming it as a cure for everything from indigestion to liver disease. The 1894 flood completely destroyed the Seltzer House, but by 1916, the water became economical again because of the immense popularity for radium water cures.

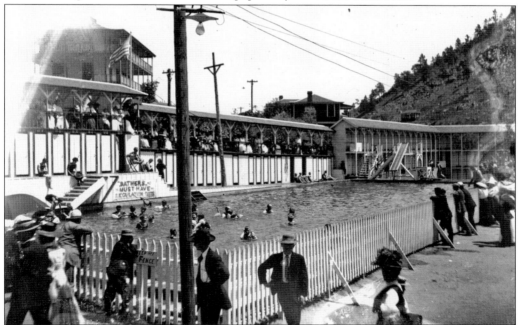

ELDORADO SPRINGS, 1900S. Known for its warm and healing spring waters, the Eldorado Springs Resort opened in 1905 in Eldorado Canyon, approximately three miles south of Boulder. Owner Frank Fowler built swimming pools, a hotel, cabins, and a dance hall. The resort captivated celebrities such as bandleader Glenn Miller, actors Mary Pickford and Douglas Fairbanks, and boxer Jack Dempsey. The hotel burned in 1940, but the resort pool continues to operate today.

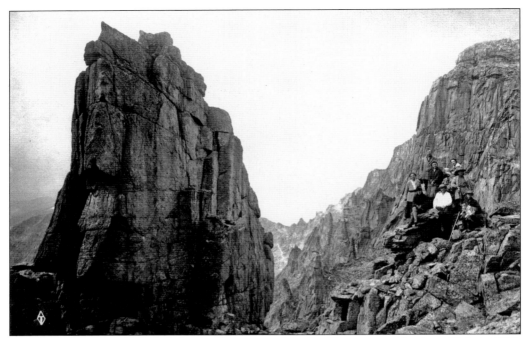

MOUNTAIN CLIMBING, 1918. Originally organized as the Chautauqua Climbers Club in 1898, the group fulfilled the Chautauqua's philosophy of exercise and health. The name changed to the Rocky Mountain Climbers Club in 1908, but it maintained a close relationship with the Chautauqua organization. Inexperienced hikers began with less rigorous goals by first taking short excursions. Later they completed day-long trips farther into the mountains, such as the group at the Denver and Rio Grande tunnel entrance in South Boulder Canyon (below). As hikers became more physically fit, the club organized overnight expeditions, including trips to the lakes near Mount Audubon (above). To many climbers, the ultimate goal was completing the trek to the top of Longs Peak, which is more than 14,000 feet in elevation.

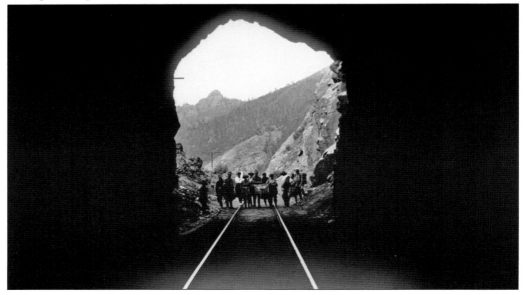

WOMEN'S BASKETBALL, 1898. The first girls' basketball team at the University of Colorado was organized in December 1898. The one outside game they played that season was against East Denver High School. Rose Longan captained the team of five players and two alternates. Six of the seven women in this 1900 yearbook photograph are likely Rose Longan, Sarah Dow, Lulu Pinger, May Carrol, Mary Elwell, and Lose Longan.

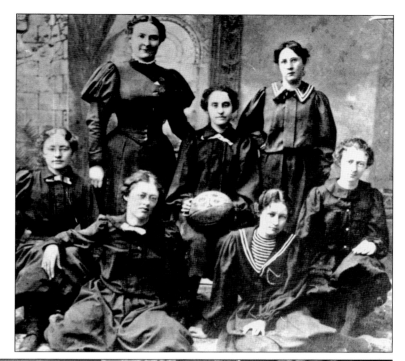

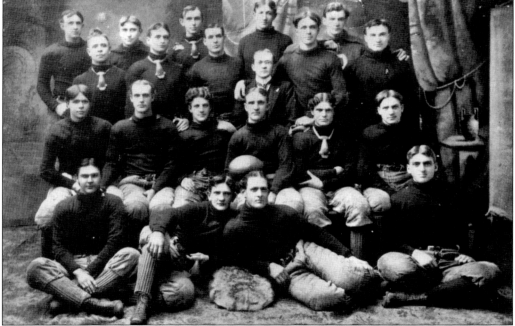

UNIVERSITY FOOTBALL, 1898. The first University of Colorado football team formed in 1889, but no games took place other than in practices. Few players understood the game, and the lack of coaching resulted in lost games and serious injuries. The team suffered a crushing defeat in 1890, losing to the School of Mines with a score of 103 to 0. Their first victory came two years later, winning 24 to 4 against the Colorado Springs Athletic Association.

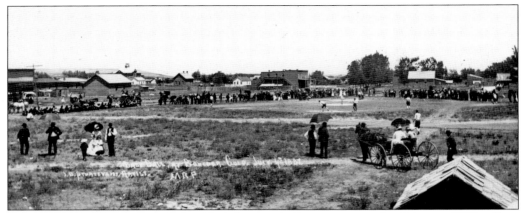

BASEBALL GAME, JULY 4, 1887. Boulder's first baseball team organized in February 1869, calling themselves the "Base Ball Club," followed a few months later by the "O Be Joyfuls." As the mining towns organized additional teams, games took place in town on the Public Square on Pearl Street between Thirteenth and Fourteenth Streets. After the construction of the courthouse on the Public Square in 1882, the open lots at Seventeenth and Pearl Streets (above) hosted many baseball games.

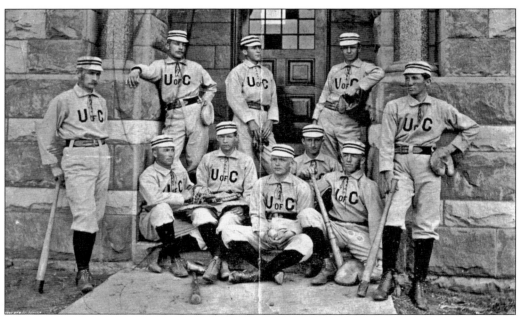

UNIVERSITY OF COLORADO PENNANT WINNERS, 1893. As the popularity of baseball grew, many primary and secondary schools had teams, as did other towns and mining companies. Some of the boys' teams received business sponsors for uniforms, and even young ladies got swinging. The early University of Colorado teams often played other town teams, not necessarily other schools. Newspapers drummed up excitement by promoting rivalries and writing lively game reports.

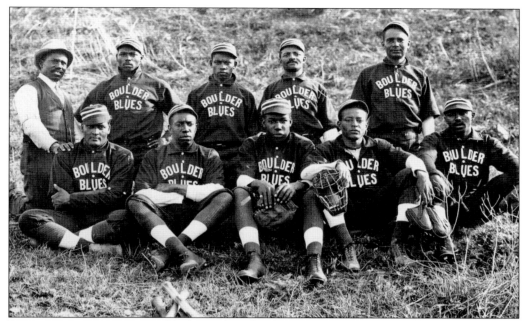

BOULDER BLUES. In 1882, Boulder boasted five baseball clubs: the Boulder Blues (originally probably the Boulders), the Reds, the First and Second Nines, the University club, and the Black Diamonds, which were described by the *Boulder News and Courier* as a "colored" team. The early Boulder Blues appear to have had a white-only roster, but this photograph reveals that the Blues eventually became an African American team. (Courtesy Carnegie Branch Library for Local History.)

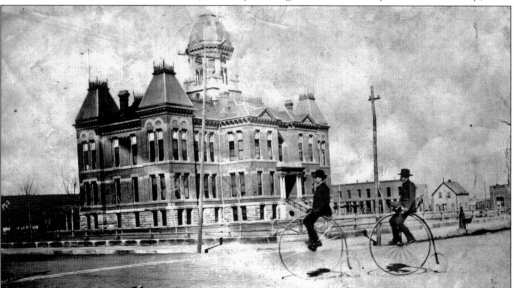

DOWNTOWN JOY RIDING, 1883. In 1869, blacksmith Peter Jasper built Boulder's first three-wheeled velocipede, also known as a "bone shaker," which proved tough to tame. In the 1870s, as technology and designs improved, the "high wheeler" bicycles came into fashion but were also difficult to ride because of the high center of gravity. Cal Moffit and William Casey demonstrate their balancing skills as they enjoy a ride downtown by the courthouse.

LOVE OF BIKING. Boulder's love of bicycling began during the 1890s when bicycle groups, such as the Boulder Wheel Club, started organizing. These clubs scheduled rides from town to town and in the mountains (above), often in coordinated clothing to identify the group. Children enjoyed the freedom and speed of riding as much as the adults. Young Otis Mulford eagerly provides a riding stance alongside his friends (left). Pictured from left to right are Ralph Sharr, Otis Mulford, and Gene Cook.

BIBLIOGRAPHY

Anderson, M. M. *The Mining Camps: Salina and Summerville*. Boulder, CO: Junction House, 2005.

Bean, Geraldine B. *Charles Boettcher: A Study in Pioneer Western Enterprises*. Boulder, CO: Westview Press, 1976.

Coel, Margaret. *Chief Left Hand, Southern Arapaho*. Norman, OK: University of Oklahoma Press, 1981.

Crossen Forest. *The Switzerland Trail of America*. Boulder, CO: Pruett Publishing Company, 1962.

Galey, Mary. *The Grand Assembly. The Story of Life at the Colorado Chautauqua*. Boulder, CO: First Flatiron Press, 1981.

Gladden, Sanford Charles. *The Early Days of Boulder, Colorado*. Boulder, CO: privately printed, 1982.

————. *Hotels of Boulder, Colorado from 1860*. Boulder, CO: Johnson Publishing Company, 1970.

History of Clear Creek and Boulder Valleys, Colorado. Chicago: O. L. Baskin and Company, 1880.

Meier, Thomas J. *The Early Settlement of Boulder: Set in Type–Cast in Bronze–Fused in Porcelain; "It Ain't Necessarily So."* Boulder, CO: Boulder Creek Press, 1993.

Noel, Thomas J., Paul F. Mahoney, and Richard E. Stevens. *Historical Atlas of Colorado*. Norman, OK: University of Oklahoma Press, 1994.

Pettem, Silvia. Boulder: *Evolution of a City*. Boulder, CO: University Press of Colorado, 1994.

————. *Legend of a Landmark. A History of the Hotel Boulderado*. Missoula, MT: Pictorial Histories Publishing Company, Inc., 1997.

Smith, Duane A., and Ronald C. Brown. *No One Ailing Except a Physician. Medicine in the Mining West, 1848-1919*. Boulder, CO: University Press of Colorado, 2001.

Smith, Phyllis. *A Look at Boulder from Settlement to City*. Boulder, CO: Pruett Press Publishing Company, 1981.

West, Elliott. *The Saloon on the Rocky Mountain Mining Frontier*. Lincoln, NE: University of Nebraska Press, 1979.

ACROSS AMERICA, PEOPLE ARE DISCOVERING SOMETHING WONDERFUL. *THEIR HERITAGE.*

Arcadia Publishing is the leading local history publisher in the United States. With more than 4,000 titles in print and hundreds of new titles released every year, Arcadia has extensive specialized experience chronicling the history of communities and celebrating America's hidden stories, bringing to life the people, places, and events from the past. To discover the history of other communities across the nation, please visit:

www.arcadiapublishing.com

Customized search tools allow you to find regional history books about the town where you grew up, the cities where your friends and family live, the town where your parents met, or even that retirement spot you've been dreaming about.